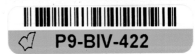

John Hedgecoe's Taking Great Photographs

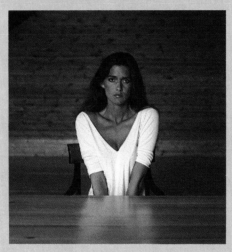

John Hedgecoe's Taking Great Photographs

Simon and Schuster
New York

John Hedgecoe's Taking Great Photographs
was edited and designed by
Mitchell Beazley Publishers Limited,
Mill House, 87-89 Shaftesbury Avenue,
London W1V 7AD

Published by Simon and Schuster
A Division of Simon & Schuster, Inc.
Simon & Schuster Building Rockefeller Center
1230 Avenue of the Americas New York,
New York 10020

First published in Great Britain in 1983 by
Mitchell Beazley International Limited,
in association with
Mitchell Beazley Television Limited and
THORN EMI Video Limited
under the title *What a Picture!*
The Complete Photography Course

Typeset by Hourds, Stafford
Reproduction by
Chelmer Litho Reproductions, Maldon
Printed in the Netherlands by
Koninklijke Smeets Offset b.v., Weert.

1 2 3 4 5 6 7 8 9 10

Library of Congress Cataloging in Publication Data
Hedgecoe, John.
 John Hedgecoe's Taking great photographs.
 Includes index.
 1. Photography. I. Title. II. Title: Taking
great photographs.
TR146.H445 1984 770'.28 84-138
ISBN 0-671-50807-5

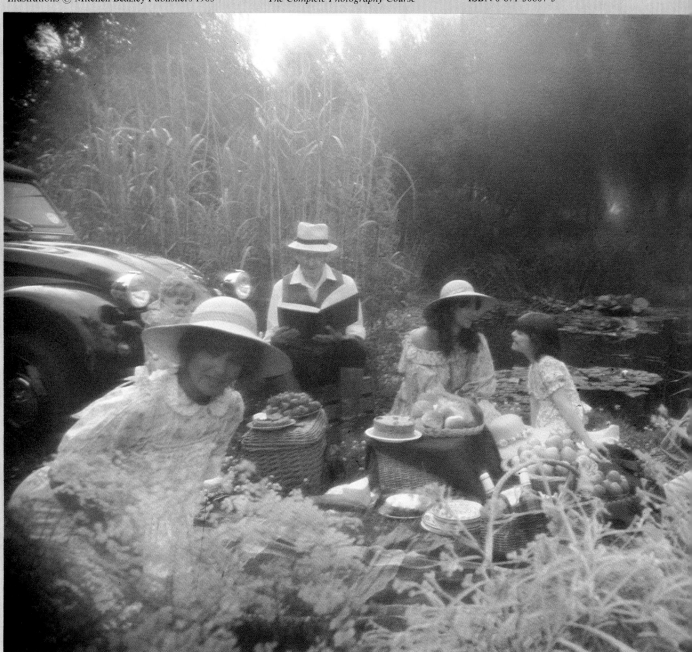

CONTENTS

INTRODUCTION

PHOTOGRAPHY, at its most fundamental level, is a pictorial record of the way an individual sees things. It is really a technique for extending and then exploiting the visual skills that we all, in some degree, possess.

My aim in *What a Picture!* is to take the mystery out of photography, in a purely practical and enjoyable way. The book is a complete introductory course that will improve your technical knowledge, increase your visual awareness, and encourage you to look, to anticipate, and to use your imagination. Your pictures will improve beyond measure, and you will quickly mature as a photographer.

As a prologue to the course itself, I have included a six-page "Technical Portfolio" describing the camera and its essential accessories, and the use of lenses and filters; the way the camera controls can be used to adjust clarity, sharpness of focus, and the illusion of movement and depth; and the basic techniques of lighting, especially the deployment of flash. This is a basic reference section which brings together, and amplifies with diagrams and photographic examples, many of the technical points made under different headings elsewhere in the book.

In the first chapter of *What a Picture!*, I look at the fundamental pictorial elements of shape, colour, form, texture and pattern. I then show how an understanding of composition and simple perspective can be used to manipulate depth and scale, and how light creates mood and atmosphere. I move on, in the third chapter, to landscape and nature photography, and in the fourth to action photography – the techniques for catching the "vital moment". Then follows a section on photographing the human body, clothed or unclothed, indoors or out, with an emphasis on poses and lighting. "Locations and Occupations" explores ways of photographing people in particular environments that express their lifestyles, interests or achievements – the farmer standing proudly among his livestock, the artist in his studio, surrounded by unfinished pieces. Next, I demonstrate the creation of unusual images as an aspect of the photographic imagination. And lastly, I look at travel photography – the art of capturing the essence of places.

In showing how to create good pictures, I inevitably have recourse to a number of technical terms. These are fully explained (and many of them illustrated) in a glossary at the back of the book. There is also a helpful appendix on caring for your equipment and for your prints or slides.

This book was conceived both as an accompaniment to a TV series and a set of video cassettes, and also as an independent book in its own right – a complete photographic primer. It is more than just a teaching manual, however. It is also intended as an annotated photographic album which will encourage you to take creative photographs by explaining the reasoning behind some of my own pictures. All the shots in the book were taken with equipment easily available to the amateur. and simple to operate. For most of them I used a medium-priced 35mm single-lens-reflex camera with a 28mm wide-angle lens, a 52mm standard lens, a 135mm long-focus lens, a firm tripod and a small portable flash. With such equipment you can tackle most photographic assignments.

The most successful photographs are those which, after the initial impact, gradually reveal further dimensions and details that stimulate the imagination. Do not be put off by mistakes and failures: we all make them, and can learn from them and turn errors to advantage. Experiment is the best way to progress. Selectivity and taste cannot be taught, but they can be acquired, through practice, and by exploring the boundless visual world that surrounds us. This voyage of photographic exploration will be challenging and rewarding – and great fun. In the process, you will sharpen your perceptions and develop a recognisable, personal style of photography.

John Hedgecoe

THE CAMERA

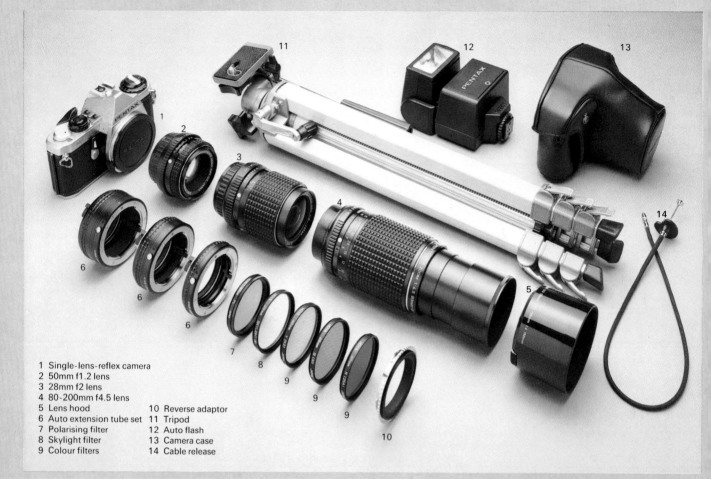

1 Single-lens-reflex camera
2 50mm f1.2 lens
3 28mm f2 lens
4 80-200mm f4.5 lens
5 Lens hood
6 Auto extension tube set
7 Polarising filter
8 Skylight filter
9 Colour filters
10 Reverse adaptor
11 Tripod
12 Auto flash
13 Camera case
14 Cable release

THE MODERN CAMERA is a technically advanced, highly sophisticated and computerised machine. Some models will focus automatically for pin-sharp pictures, wind on your film automatically, and even light the subject with the desired amount of light from the computer flash, an acceptable picture every time.

There is no doubt that the most popular camera design is the compact, lightweight single lens reflex (SLR) such as the Pentax ME Super, shown above with its basic range of accessories. These can be extended to include a great variety of additional equipment and interchangeable lenses to provide exceptional versatility. The SLR conveys the image formed by the lens via an angled, reflex mirror to a focusing screen, where you can view it as you compose and focus the picture. SLRs take 35mm film, and their exposure

controls may be manually-operated or automatic, while some models have provision for both modes. When you take a photograph, the light reaching the film has to be precisely controlled, otherwise the image would be too light or too dark. The camera achieves this with a light-sensitive meter linked to a shutter in the camera and the aperture in the lens. Both can be varied to coordinate with each other to control light entering the camera – the shutter in speeds of fractions of a second, the aperture in gradual steps, or "stops".

Automatic exposure systems adjust the aperture size, or the shutter speed, or both automatically to give correct exposure on the basis of the light reading. With "aperture priority" you select the aperture and the camera adjusts the shutter speed. With "shutter priority" you select the speed and the camera adjusts the aperture.

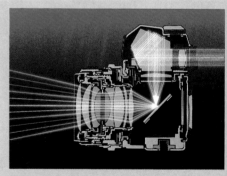

The single-lens reflex system works as follows. Light rays passing through the lens are reflected up by an angled mirror to a matt-surfaced focusing screen, which shows the image exactly as it will reach the film. A prism bends the light so you can view the screen with the camera at eye level. It also shows the image the right way up and around, although the lens has inverted and reversed it. When you press the shutter button the mirror lifts and the shutter opens, to allow the light image to reach the film.

Exposure information *is often displayed in the viewfinder. Manual cameras have a needle to show when the exposure is correct. Many modern cameras employ light-emitting diodes (LEDs) instead. Some displays glow green for correct exposure. Automatic cameras usually display actual settings, sometimes digitally.*

MANUAL METERING

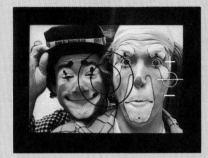

LIGHT-EMITTING DIODE (LED)

AUTOMATIC LED

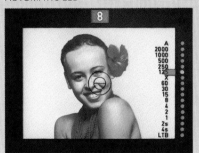

DIGITAL LED

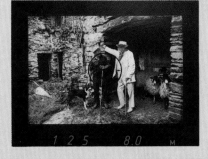

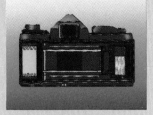 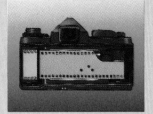

To load the camera, *open the camera back and slot the film cassette into its compartment. Pull the tapered film-leader out and insert it into the take-up spool, making sure it is firmly attached. Move the film advance lever until the sprocket holes engage with the* geared spool.

Close camera back and advance film lever twice, pressing the shutter release if necessary. Ensure that the film is winding on: the rewind handle should spin. Set the ASA number on the film speed dial.

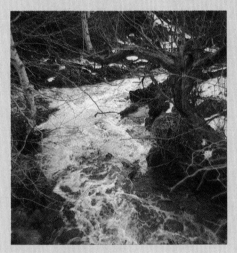 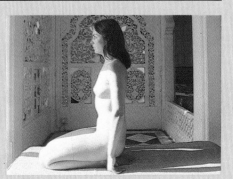

Shutter speeds *determine whether motion can be arrested or allowed to appear as a blur. They are measured on a scale of fractions of a second, from 1/1000 or faster, down to 1 or 2 seconds. In the shot* above, *the stream's movement has been "frozen" with a speed of 1/250. Using a slower speed of 1/30 has produced a blur. Static subjects, of course, appear sharp even at slow speeds if the camera is still.*

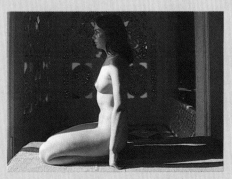 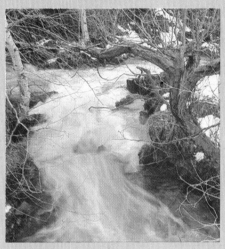

Manual over-ride *of automated systems is useful where you wish to control exposure finely, particularly to include detail in shadow areas. Automatic exposure (above) gave a correct reading for the skin tones, but lost* background detail. Marked contrast between light and dark areas needed separate readings – one for shadows, another for skin tones, then selecting a mean exposure. This gave slight over-exposure for the girl, unavoidably.

LENSES

CAMERAS USE A CONVERGING LENS to form the subject image on film. Light from near subjects is brought to focus further behind the lens than light from far subjects. So to focus nearer subjects on the film plane, the lens has to be moved outwards by turning the focusing ring. At infinity (∞), and with a small aperture, a standard lens will show most of a scene in focus, from about 4 metres (14 feet) to the far distance. Modern lenses are made up of six or more shaped elements (i.e., individual lenses cemented together). Lenses come in a variety of focal lengths (the distance between lens and film plane), each having a different field of view, showing subjects larger or smaller in the frame. A 50mm lens is standard for a 35mm camera; longer lenses (e.g. 135mm) give a bigger image of a smaller area; wide-angles (e.g. 28mm) take in more of a scene, showing subjects correspondingly smaller.

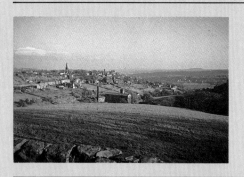

The four pictures (left), all taken within a few minutes of each other, differ only through a change of lenses. The exposure in each case was 1/125 at f11.

*A **wide-angle lens** (28mm) includes some of the foreground wall, and definition is perfectly sharp throughout. With very wide-angle lenses, focusing becomes less critical, even at wide apertures, because the depth of field is so extensive.*

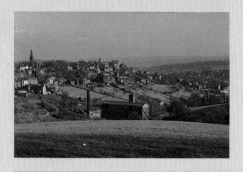

*A **standard lens** (50mm) cuts out the immediate foreground and shows a more confined area, but still produces excellent foreground definition. A standard lens presents subjects at a size approximating to the view seen by the human eye, giving a "normal" relationship between different image planes. This lens offers the widest maximum apertures, often as large as f1.2, which is useful in dim light. It is a good general-purpose lens for 35mm cameras.*

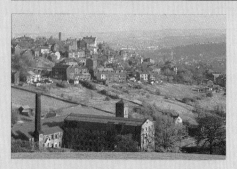

*A **long-focus lens** (105mm) narrows the angle of view even further, and cuts out the church. The town has been reduced to the immediate surroundings of a wool mill, which begins to dominate the scene. Haze seems to thicken in the valley as the lens brings up more distant features. Lenses of medium focal length, from 80mm to 105mm, are useful for portraiture. Longer lenses become progressively heavier; for those over 200mm you really need tripod support.*

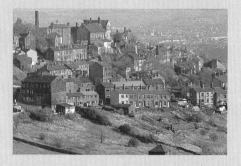

*A **zoom lens** – a very useful addition to your range if you already own a wide-angle and a standard – will give you a variety of longer focal lengths in a single lens. A typical zoom can offer a range from 70mm up to 150mm or 210mm. Taken at 200mm with a zoom lens, the picture now includes only the central parts of the scene, showing the form of distant buildings well despite the softening of haze. Very little remains of the mill in the foreground.*

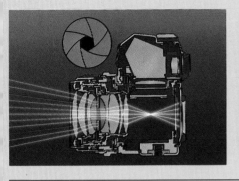

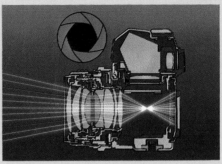

The aperture determines how much *light enters the lens, and controls exposure together with the shutter, which determines how long* this light will act on the film. *Aperture size is regulated by an iris diaphragm, controlled by a ring on the lens marked in f numbers, or "stops". The range varies from around f2 (widest) to f16 or 22 (smallest). The aperture also affects sharpness. Narrowing the iris diaphragm gives an extended zone of sharpness, or* depth of field *(see below).*

Depth of field varies with focal length, with aperture, and with focused distance. The longer the focal length of a lens, the narrower the depth of field it will provide at a given aperture and focusing distance. A telephoto lens gives very shallow depth of field, a wide-angle lens an extensive one. The depth of field scale on any lens mount shows that depth of field alters with subject distance, becoming greater as you focus further away.

Suppose you have focused the camera at 2.5ft (the middle scale on the lens) and set an aperture of f8 (bottom scale). The divisions marked 8 on the depth of field scale (top) indicate the extent of sharpness – it runs only from 2.3 to 2.7 ft, depth of field being very

shallow. So focusing must be precise for close-up shots. The bottom diagram shows that if you keep the aperture at f8 and refocus the lens to 20 ft the depth of field increases to run from about 11 ft to infinity. (You can gain fuller advantage of depth of field by using the hyperfocal distance; see p30.)

The two shots beneath show the effects of aperture on depth of field. At f2 on a 50mm lens, focused on the girl in the foreground, the remainder of the scene is blurred. Maintaining focus on the girl, and stopping down to f22, the companion figures and house are brought into sharp focus.

With many SLRs you can preview depth of field in the viewfinder.

Selective focusing is a simple technique for isolating the subject from the background (below) or for framing a distant subject with a blurred foreground (bottom) to give a sense of depth.

Focusing on a subject in the foreground and using a wide aperture, say f2.8, causes the background to become a blur and thus places emphasis on the foreground. With the same wide aperture, but focusing at infinity, you can create foreground blur. A 200mm long-focus lens was used to frame the cathedral with copper beech leaves thrown out of focus by the lens' very limited depth of field.

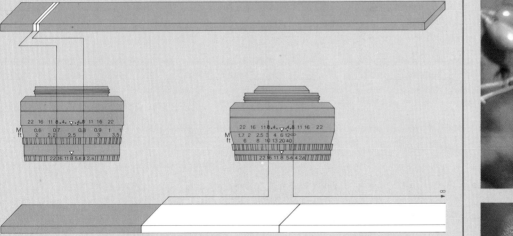

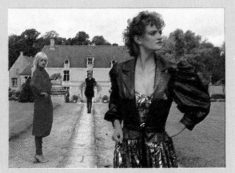

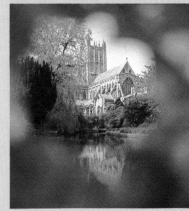

FILM AND LIGHTING

TWO MAIN TYPES OF FILM are available: colour negative film, from which unlimited prints can be made for direct viewing; and colour slide or transparency film, for viewing when projected on a screen. The most popular film format is 35mm, available in a cassette of 20 or 36 exposures. Film is rated according to its sensitivity to light. A "fast" film can record pictures in poor light, while a slow film achieves finer detail but requires more exposure.

Film speed is now rated by the ISO system, which corresponds exactly with, and is gradually replacing, the ASA system. For general purposes you should choose a medium-speed film from ASA 60 to ASA 100. Slide films are balanced for either daylight (Type A) or artificial, tungsten light (Type B). Daylight film can be used with most kinds of flash, so you will seldom need Type B. When you buy film, check whether the price includes processing.

Long exposures can be made in weak light if the subject keeps still. The match was the only source for the shot below (1/15 at f4 on tungsten film). For firework displays, use long time-exposures at medium apertures, with medium-speed daylight film. The shot below was given 18 seconds, the lens covered between bursts.

SINGLE IMAGE

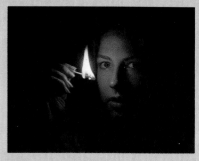

MULTIPLE IMAGE

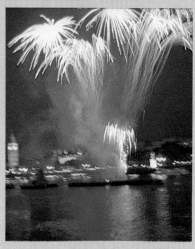

Filters are used to block or transmit a specific part of the light. Ultraviolet (UV) filters penetrate haze in landscapes giving a clearer image (below). They are useful on longer-focus lenses. A skylight filter has a similar effect and makes skies slightly bluer. A neutral density filter reduces brightness and depth of field (since you have cut down the light you can use a larger aperture) and enables fast films to be used in strong light. A polarising filter cuts down reflections and intensifies blue skies – twisting the lens aligns the filter screen to block polarised light (diagram and pictures right).

ULTRA-VIOLET (UV) FILTER

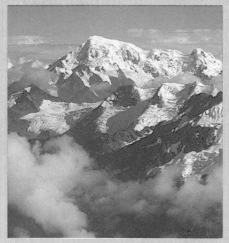

POLARISING FILTER

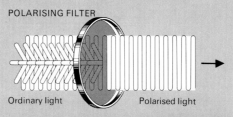

Ordinary light Polarised light

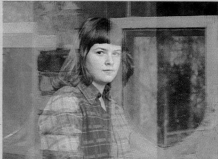

WITHOUT POLARISING FILTER△ ▽WITH

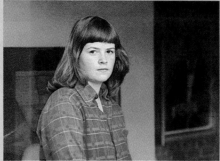

On a manual exposure setting you can vary the exposure a stop either side of the recommended reading and still get acceptable results. Slight underexposure makes colours richer. At f1.2 the subject is far too pale, and at f16 too gloomy. f5.6 is ideal, and f4 and f8 acceptable.

f1.2 f4 f5.6 f8 f16

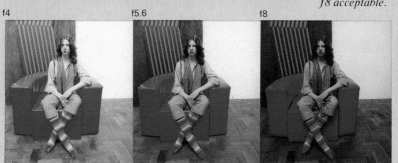

Film type has a marked effect on a picture's colour values. Daylight film, in artificial light, records an orange cast and gives a warm effect. Tungsten film *in artificial light has rendered the same interior with a greenish cast. Electronic flash with daylight film (artificial light switched off) has given truest results.*

DAYLIGHT FILM

TUNGSTEN FILM

DAYLIGHT FILM / ELECTRONIC FLASH

INFRA-RED FILM

Electronic flash systems take from 4 to 30 seconds to recharge between shots, depending on flash/subject distance. This distance is the main factor governing correct exposure, and a calculator dial on the unit enables you to judge exposure accordingly. You set the film speed on the dial, measure the total distance light has to travel (from flash to subject), then read off the aperture.

WITHOUT FLASH

WITH FLASH

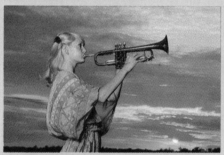

A flash unit on the camera's "hot shoe", pointing at the subject, is the simplest way of providing flash. But results tend to be flat with hard shadows, and this technique may create "red-eye" in portraits, when light reflects from the subject's eyes.

Flash bounced off a ceiling or white wall gives a softer and more pleasing result. If you bounce off a coloured wall you may get a colour cast. In calculating the right aperture, you must allow for the extra distance bounced flash travels before reaching the subject.

Flash held off-camera on a long extension lead will give better modelling. If your flash system has a slave unit, use it at a distance to fill in shadows. If you have a clip-on diffuser for the main flash head you can use it direct, to soften modelling and shadows.

Flash bounced off an umbrella reflector gives better directional control. Commercial models mounted on a stand, and smaller, nonprofessional ones, are available, but a substitute can be made by painting an old umbrella white or silver.

Flash can be used to lighten or "fill-in" heavy shadow areas even in bright sunlight: set the exposure according to the camera's meter reading for highlights or mid-tones. Some electronic flash units have fill-in settings or secondary, low-power tubes. Alternatively, you will have to increase flash/subject distance with an extension lead, or bounce the flash off a white reflector.

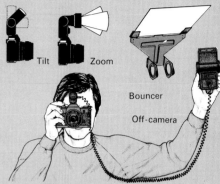

Tilt Zoom

Bouncer

Off-camera

Bouncing flash. to soften the light, can be achieved by an off-camera flashgun (above), or by a tilt gun with a bounce card over it. The zoom flashgun is designed to intensify or diffuse the emitted light as desired.

Flashguns come in three main systems (below right). For non-computer flash, aperture depends on flash/subject distance. The "dedicated" system, an advance on computer flash, regulates the flash output by means of the camera's built-in meter.

NON-COMPUTER

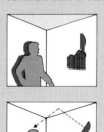 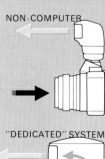

"DEDICATED" SYSTEM

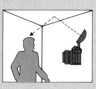 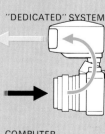

 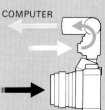

COMPUTER

THE VITAL ELEMENTS

THE ANATOMY OF A PICTURE depends on a few vital elements: shape, tone, form, colour, pattern and texture. These all depend in turn on the direction and quality of light falling on the subject. Light is fundamental to all the other vital elements. Your camera, film and choice of subject are important, but light alone can give your picture colour, texture, and detail, and create mood, atmosphere, and depth.

If the source of light is directly behind the subject, then you see only a black, solid shape – a silhouette. Shape, the first of the vital elements, can sometimes provide as much impact and drama as a picture full of colour, pattern and texture. A subject lit from one side, instead of from behind, will introduce two further elements: colour and tone. Tone is the range of shades from highlights to shadows; it is this that gives you form and texture. Form is the depth and apparent solidity or volume that your subject has now acquired. Side-light may also bring out texture – the roughness or smoothness of a surface. Finally, the repetition of a motif such as leaves on a tree adds the element of pattern, and can provide rhythm in a picture.

SHAPES WITHIN SHAPES enliven both these pictures, though they differ in mood and subject matter. Both contain all the important elements: the picture below has shape, colour, form and tone. It also has pattern (the flower-pots) and, in addition, the texture and softness of the flower.

The clown picture (right) has a bulky shape against a flat pastel-shaded background. His face, his hands and his clothes are modelled by changes of tone, while pattern is evident in the background. The strong, jazzy colours give the whole picture great zest, but even in black-and-white the other elements – pattern, shape, texture – would create a strong picture.

All the elements *are at work in these two dynamic compositions. The broad, simple shapes contrast with the detail of texture and pattern, and the interplay of the highlights and shadows.*

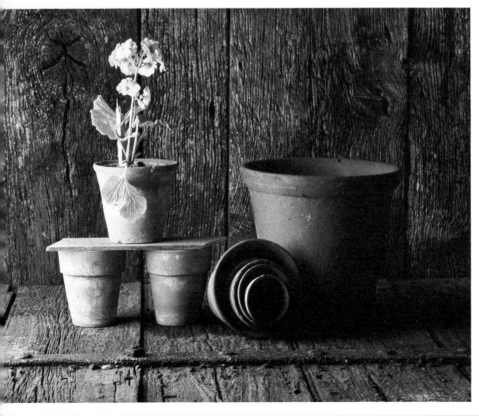

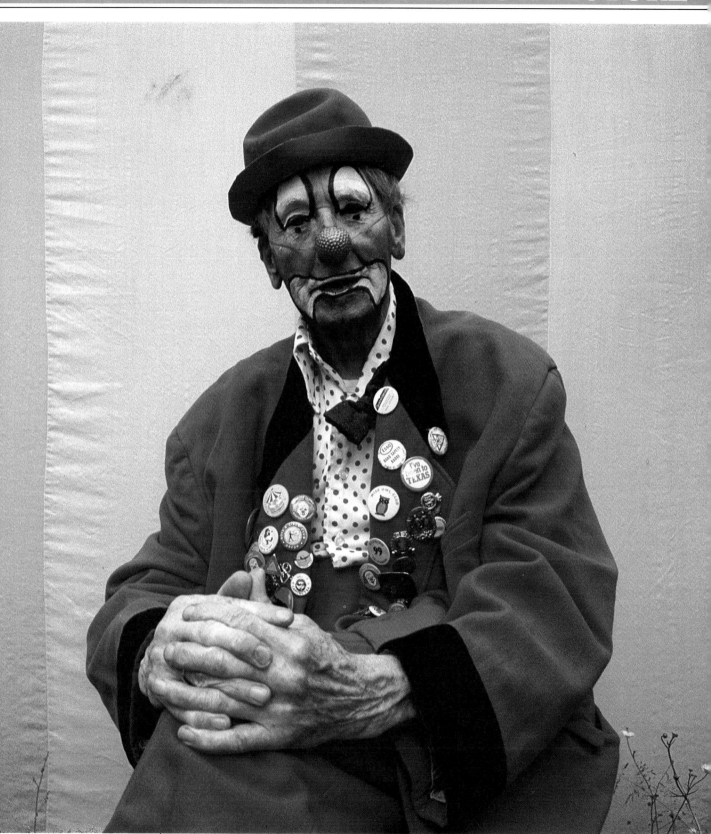

SHAPE AND SILHOUETTE

A FAMILIAR SHAPE helps us to recognise an object, often more swiftly than any other feature – although identification is more difficult if we view only a part of the object, or see it from an unusual angle. The shapes in the picture below, all silhouettes with the light behind the subject, are familiar to most of us. Recognition is immediate because the entire object is visible – the tree and jug, the vase of dried flowers – and because the camera has been placed in such a position that salient features are clearly defined. Friends of the man with a stick (bottom left) would probably recognise him right away; but the head and shoulders of the girl might provide insufficient information without additional light to give some modelling to her features.

The position from which a shape is photographed is important in making it recognisable: if we gave the jug, in the fourth picture , a quarter-turn, the handle would be lost in shadow and we might fail to see it as a jug. Silhouetted pictures of people in action will convey more information if they are shot in profile like the graceful dancer (right).

Shape and shape alone, without any form, can often have the most impact and drama, especially in black-and-white, because there are no other elements to confuse the eye with supporting information – neither colour, nor form nor texture. The picture of the tree, for instance, has a stark yet delicate simplicity, helped by an additional element of pattern: notice how the complex network of the branches is nicely balanced against the dark, solid rectangle of the foreground. Don't ignore the possibilities of pictures based on pure shape: such simple subjects frequently make most effective photographs, and fairly intricate images in silhouette will read very strongly.

The most basic of the pictorial elements, shape helps you select and arrange a subject so that other factors fall more readily into place.

BACKLIGHTING from a brightly-lit window will give you the most favourable conditions for silhouette pictures. You can then use fast shutter speeds – as I did for the picture of a dancer (right). I took the exposure reading from the light coming through the window. Notice that the outline is very clearly defined, with no extraneous light or distracting detail.

You can learn a lot about photography by arranging still-life silhouettes. Start with a simple object, such as the soda syphon (far right), as the basis of your group. Then add other sympathetic objects and shapes, structuring the arrangements with careful regard to the composition and to the pictorial effect.

Silhouetted shapes (below) *need a light, plain background. In landscapes, the sky gives ideal contrast for silhouettes. Objects indoors can be arranged against the light from a window, or an opaque screen with the light behind it, or light "bounced" off a white wall.*

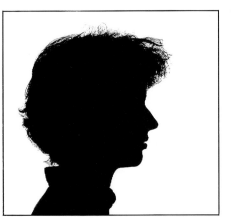

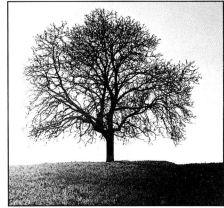

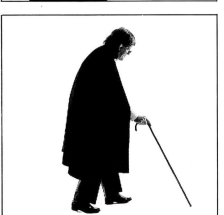

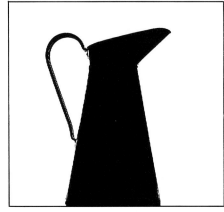

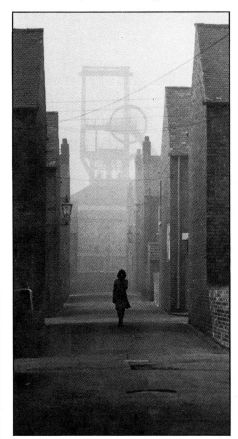

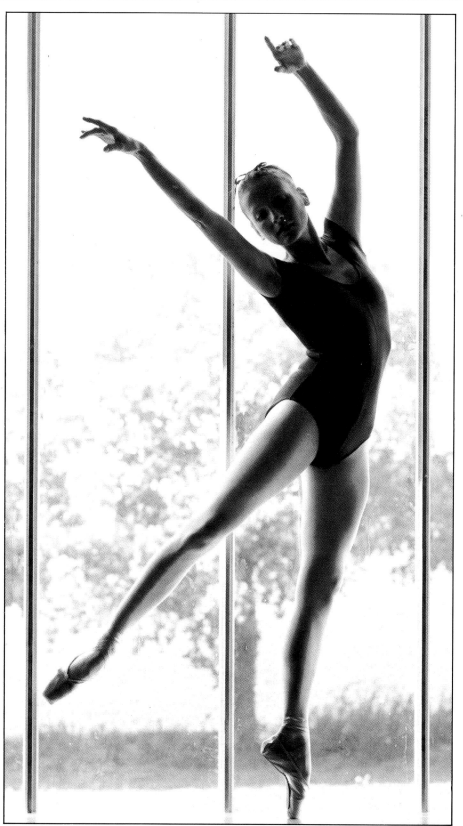

Shooting against the light means you can use fast shutter speeds and "freeze" movement (see pp66–67). Take a reading for the lightest part of the background. I shot this dancer (left) in a sequence of poses, at 1/250 second.

Building a still-life (below) starts from one simple shape and leads to a complete group. To emphasise shape, start from a low or level viewpoint. Notice how in the last two pictures a single, oblique light adds a degree of modelling and reveals form.

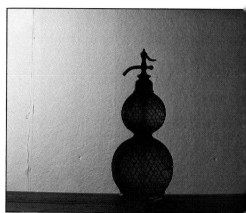

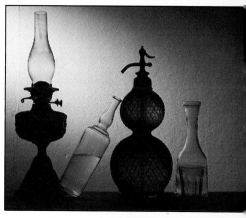

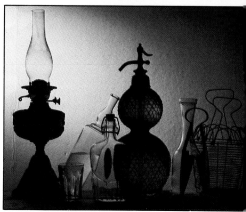

COLOUR

COLOUR, A VITAL ELEMENT of photography, needs to be used with discretion: it takes skill to use it to the best advantage. Strong colour can overwhelm weaker, more subtle features, while muted colours need a sensitive approach to record successfully.

We are impressed when our film has captured the full impact of vibrant red, or a shimmering yellow. But subtler scenes with limited colour, or perhaps a single accent of bright colour isolated in a dull background, can have more appeal.

One of the most important characteristics of colour is its effect on mood and atmosphere. It can also help the structure of a picture: subtle colours, with a blending of tones, give your landscape shots a feeling of depth and distance. Conversely, strong warm colours come forward, and can produce a dynamic, dramatic effect.

Colours close to each other in hue – such as reds and pinks – create harmonious effects when juxtaposed. A touch of contrasting colour will stand out, and add a sense of vitality. Large areas of contrasting colour – like blue and yellow – can have a bold, even jazzy, effect. But too many colours can destroy a picture's structure or mood.

Rich colours, pattern and texture need a simple, non-competing background, as in the colour shot (facing). I used a 135 mm long-focus lens to reduce the depth of field and keep the setting out of focus.
Related colours create harmony (above), while strong reds stand out boldly from the background as in the group of circus folk (below).

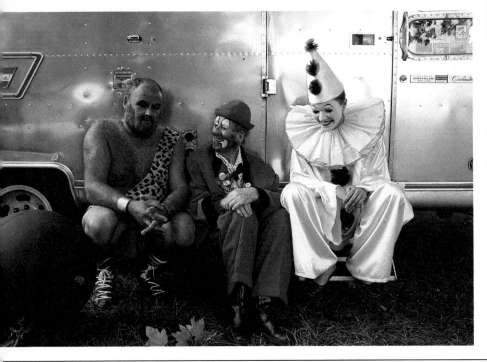

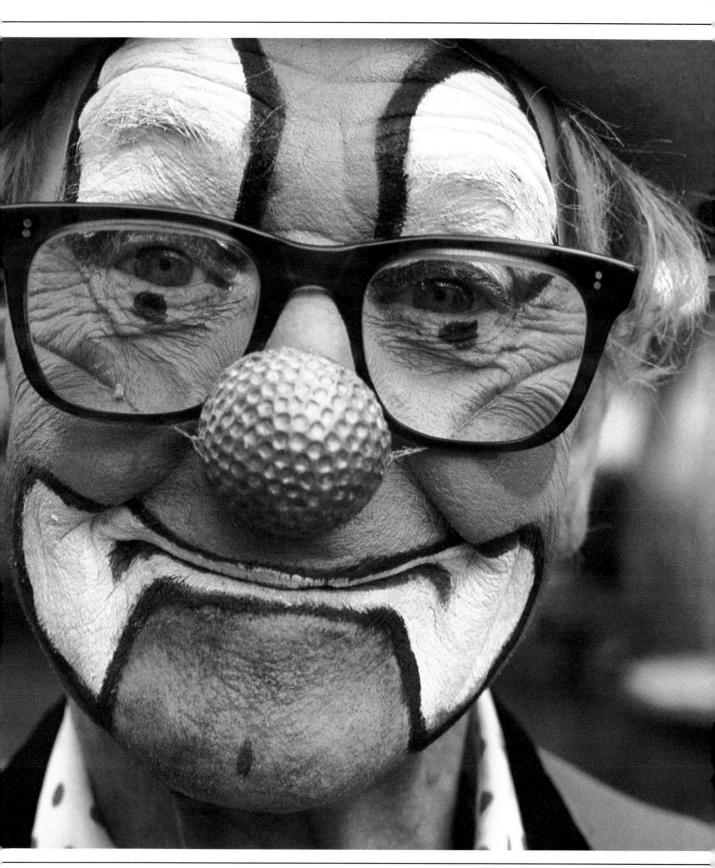

FORM

SOLIDITY AND DEPTH, and the illusion of three-dimensional form in a picture, depend on the ability of your camera and film to record a range of tones, from brightest highlights to darkest shadows.

Photographers refer to the relationship between the highlights and shadows as the tonal range of a picture. Although film can record the finest subtleties of tone, if the subject is too contrasty you usually have to sacrifice one extreme of the scale or the other.

The combination of lighting and exposure can create an almost infinite scale of subtle tone progressions. And it is these tones – the variations of lightness and darkness across a surface – that tell us whether an object is smooth, rough, thick or thin, rounded or flat, and whether it has solidity and depth.

The subtleties of form are controlled by the direction and the quality of the lighting. By "quality" we mean whether the light on the subject is harsh and direct (like the summer sun at midday) or soft and diffused (as at dawn or dusk).

Harsh light can suppress form by destroying the delicacy and range of intermediate tone. Diffused light, angled so that it follows the direction of the form, produces a fully-realised impression of solidity and depth, with good modelling of rounded surfaces. Softening the light by redirecting it off a reflective surface, or by putting a diffusing medium such as tissue paper in front of the lamp, gives best results.

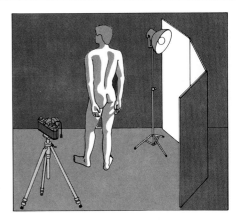

Lighting the human form for this shot (right), I used a straightforward technique, placing a three-sided screen (see the diagram, above) to illuminate the form against a dark background. The light was "bounced" off the walls of the screen and on to the figure.

The white jug and basin (left) provided an excellent – and not altogether easy – subject for lighting. The jug was lit by three different arrangements (below), which show how form, shape and texture can be either destroyed or emphasised.

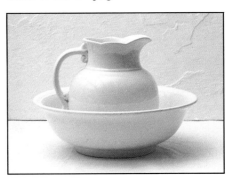

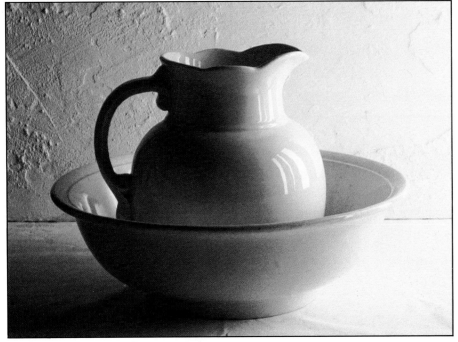

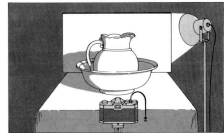

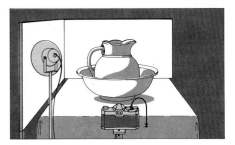

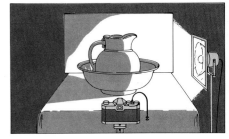

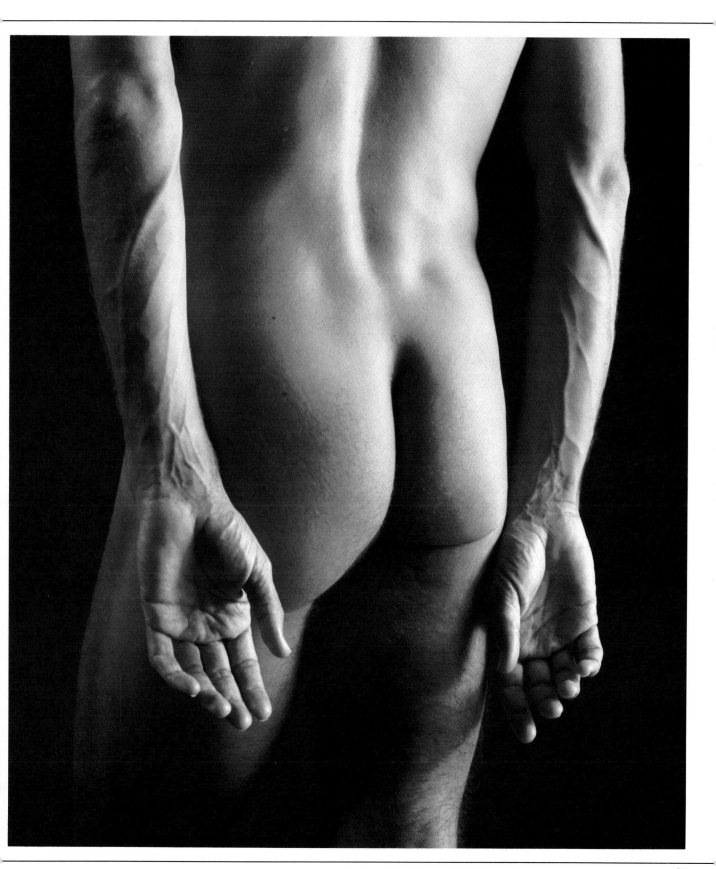

TEXTURE

TEXTURE shows the nature of objects, giving pictures a vivid actuality. When a surface is raked by oblique, directional light, casting strong shadows and highlights, texture is revealed by the irregularities of the material. The effect can be softened by diffused lighting, or by light reflected into the shadows; but texture is destroyed by frontal lighting. The difference is illustrated in two shots of a Norwegian mountainside (below).

Moving in close to a surface with your camera lens will allow you to record the smoothness of eggshell and the roughness of canvas. The close-up of the padlock (right) was made in diffused sunlight. It shows very clearly the nature of the materials – the pitted, rusty character of the iron, the bright, worn steel of the lock, the weathered wood of the door.

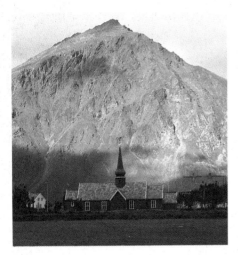

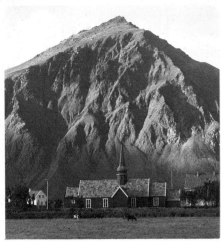

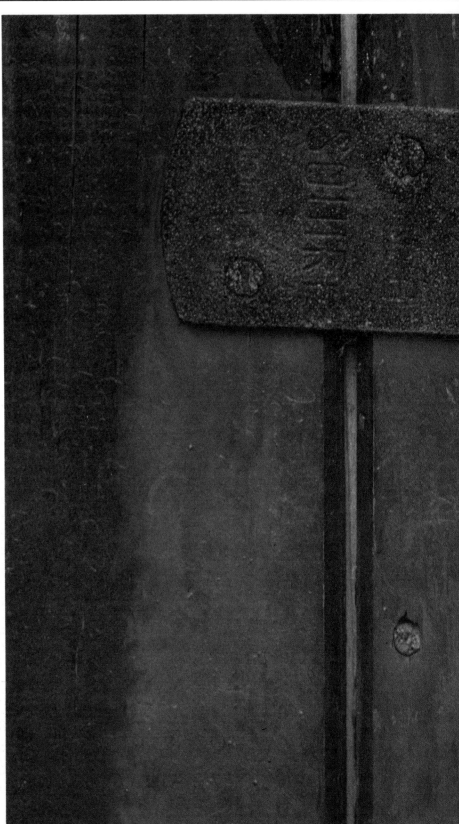

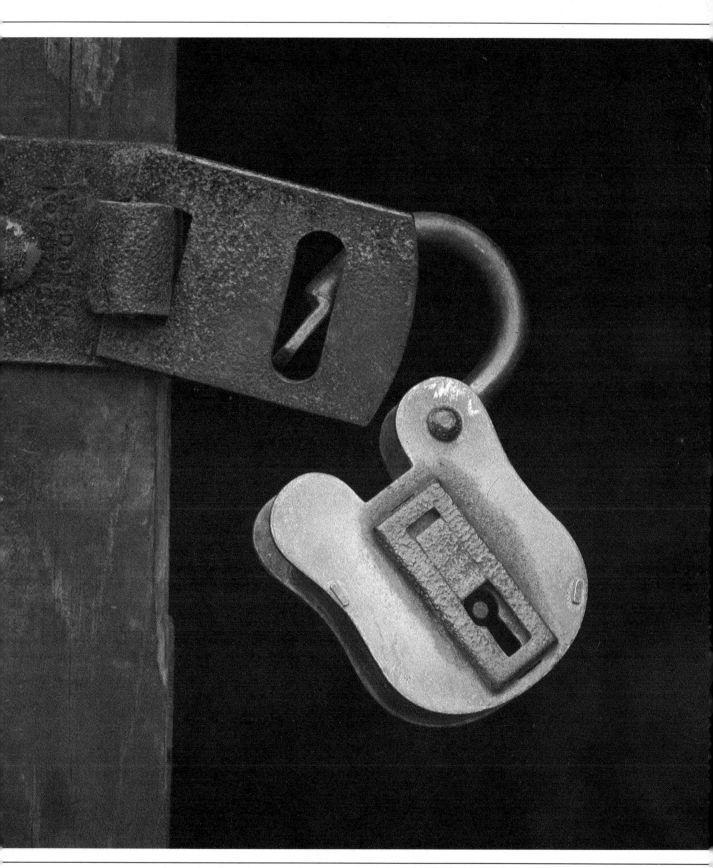

PATTERN

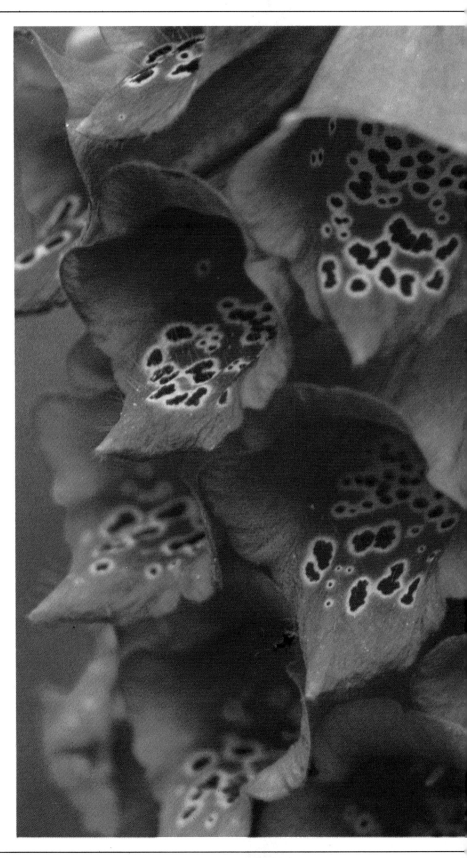

T HE PICTORIAL STRENGTH of
pattern, and the symmetry of recur-
ring shapes, help to give your pictures
rhythm, structure and bold composi-
tion. Patterns are generally pleasing to
the eye: there is something reassuring in
their disciplined arrangement of shapes,
their harmonious geometry, their
decorative charm.

The relationship between pattern
and texture is close, but whereas texture
is often best revealed by oblique light-
ing, images with strong elements of
pattern are more suited to flat, diffused
lighting, with the light source near to or
behind the camera.

PATTERN AS THE DOMINANT

AREA of an image tends to flatten the
subject itself; its effect is strongly two-
dimensional, and form becomes
minimal in your picture. This quality of
flatness is stronger in close-up,
especially where the subject is set
against a complex or confused back-
ground. The foxgloves would have lost
their flat symmetry (right) if the sur-
roundings had been included in the
picture, or they had been shot in direc-
tional light instead of diffused sunlight.
Strong, oblique lighting can be useful,
however, to create pattern in a boldly
textured surface such as that of the
ploughed field (far right, top) – the
steep perspective adds rhythm.

You should be constantly alert to the
scope and potential of pattern: the
repeated motif of rooftops flattened
through a long-focus lens; of windows
in the facade of a building; and the
wonderful, inexhaustible supply of
patterns found in nature everywhere.

Don't overlook such everyday,
simple images as the row of bleached
and worn handles or the stored flower
pots (far right). The shapes are similar,
and the repeated motif blends with the
effects of the faded, monochromatic
colours and the rough, workaday
textures.

*Delicate foxglove flowers in close-up reveal a
pattern within a pattern. The diffused sun-
light produces strong colour, where harsh and
oblique light might have created heavy
shadows and destroyed the pattern.*

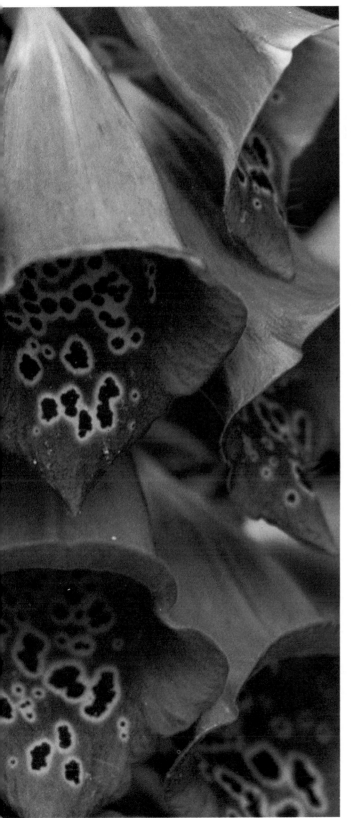

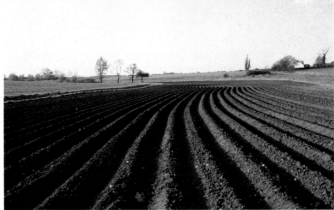

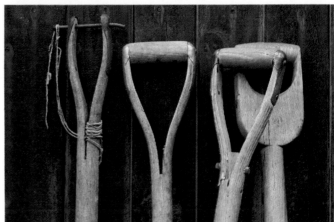

Pattern is the repetition of shapes, *but it need not be wholly regular or ordered. These patterns in a rural setting, above, are irregular but offer quite arresting images to the photographer – the furrows of the field in sunlight; the fork and spade handles (one is broken); the flowerpots with one offset to break the symmetry and to provide a more dominant element of shape.*

COMPOSITION simply means arranging and juxtaposing the elements of your picture into a satisfying balance of colours, shapes, and tones. The order of arrangement, and the emphasis you lay on each element, is entirely up to you, reflecting your judgement, skill, and most of all how you feel about the subject. With an immovable subject like a building, composition depends mainly on how you frame the picture. But where the subject has movable elements, as in the studies here, you can place them how you wish – still life is a good way to begin to explore composition. In effect, you are "composing" in the same way whenever you arrange flowers, or furniture in a room.

The rules of composition are regularly broken. You should, however, always try to have a dominant object in a picture, supported by other, subordinate objects.

Everything in your picture must have a reason to be there – an area of strong colour to balance a softer one, a shape to echo others, which together make an overall shape, like the pyramid of loaf-shapes (right).

An interplay of shapes supports the dominant image of the scissors (below). *The powerful form of the pyramid (right), aided by linear perspective, leads the eye to the middle distance, and to the chateau beyond.*

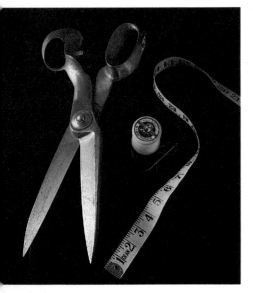

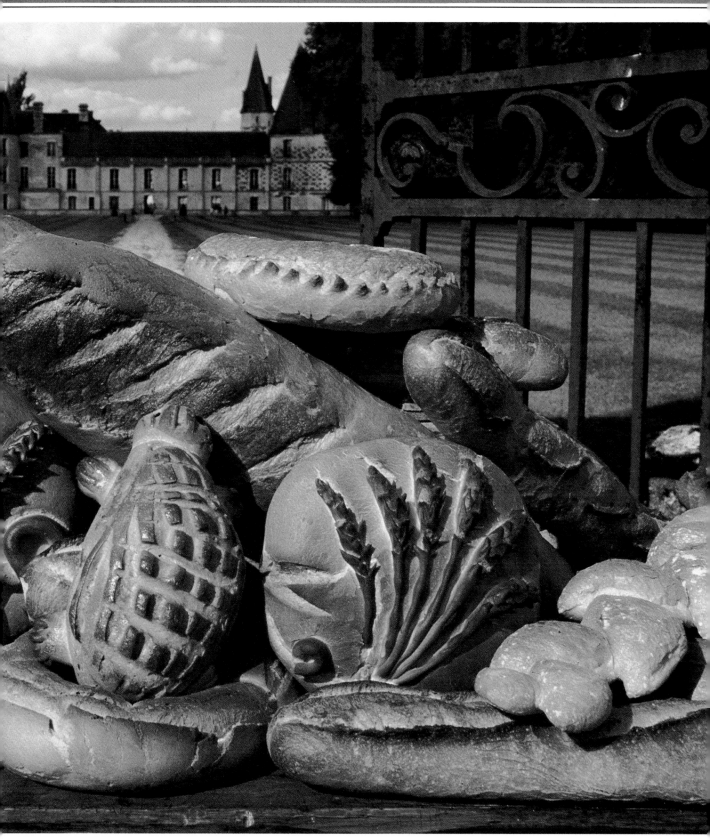

LIGHTING AND FRAMING

T HE LIGHTING ON YOUR SUBJECT will affect your composition – its direction alters the angle of shadows and its quality, soft and diffused or harsh and bright, deter- mines their density and also sets a mood. Particularly when strong sun- light casts dark shadows, with equally assertive highlights, you will see shapes, lines and patterns form, which you must take into account.

Composing a fixed scene – a land- scape or street setting, or any subject where you cannot move the elements to please yourself – depends on your view- point, camera angle, and framing. By moving around, you can radically alter the way one element of a scene relates to another, shifting the direction of lines or patterns, changing the size of objects, and juxtaposing new shapes and colours.

FRAMING is your first consideration. You must decide whether the dynamics of the subject tend to the vertical or to the horizontal. Most cameras give hori- zontal framing when held normally; encouraging people to frame every subject horizontally, whatever its shape. But this may cut the top or bottom off a tall subject, or include too much extraneous detail in the sides of the frame. Get in closer to fill your frame with the subject and where it is obviously vertical, hold your camera this way. Use your frame to isolate the important features of a subject. Don't try to put too much in a picture – learn to see what you can leave out.

Snack between meals with a sharp flavour – the dynamic vertical thrust in the shot of a sword-swallower (right) would have been lost had I framed it horizontally.

Horizontal or vertical? Both pictures have equal merit (facing page, top), because the main area of interest – the trees and poppies – forms vertical bands in the horizontal panorama. Choice of framing here relies on aesthetics, rather than rules of composition.

The tall tree (far right) almost divides the picture, giving a main, vertical element to composition. But the background landscape is the subject – hence the horizontal framing.

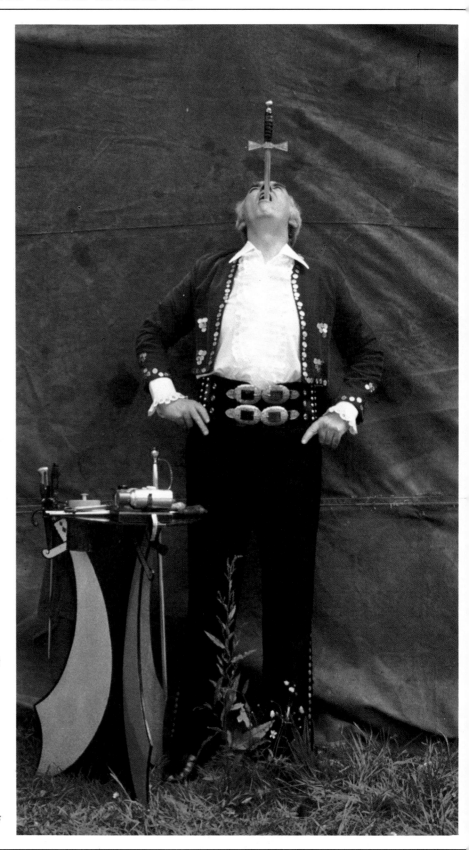

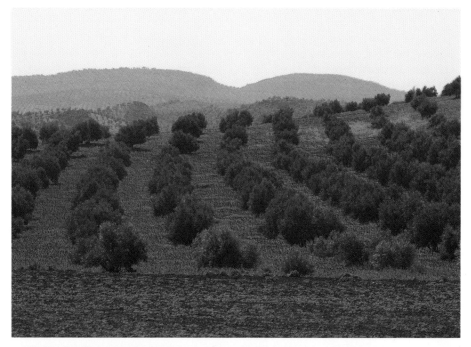

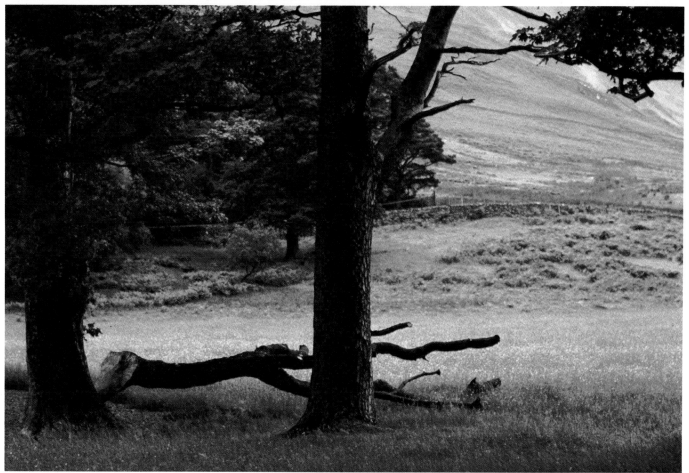

BACKGROUNDS

BACKGROUNDS ARE AN INTEGRAL PART of a picture. Whether you exploit or ignore them, they will greatly influence the mood and clarity of your photograph, and you must train your eye to see their potential. Achieving a balance between the background and the subject is a matter of judgement – but in any situation there is almost certainly a number of interesting options. You can shift the emphasis from foreground to background; change to a lower or higher camera angle; and place your subject against a variety of settings from different viewpoints.

Plain white or colour backgrounds can increase dramatic content, empha-sise shape and simplify the picture. Tonal backgrounds suggest different moods and can provide contrast for the subject – light on dark or dark on light. Strong and repetitive patterns are not easy to control because they tend to overpower and dominate the subject, but they can also bring order and rhythm to a static and otherwise dull feature.

A background should always be subordinate to your subject and not overpower it (though there are successful pictures where it is difficult to determine which is the more dominant feature; rules, as always, are made to be broken). An alternative is to avoid the issue by not having any background features at all.

You can eliminate an unsuitable background by selective focusing with a wide aperture or a long lens. This will effectively isolate your subject from its setting, bringing it into greater prominence while the background becomes a mere blur. (As you will have discovered, a wide open aperture destroys depth of field.) On the other hand a detailed, recognisably clear background is often necessary to add supporting information about the main feature of your picture – a coal miner against the gaunt silhouette of the pit head, a fashion model in the elegant surroundings of a couture house, a fisherman surrounded by his day's catch.

Apples in a basket *(right) against a selection of backgrounds. All except one (the tiles) were shot in oblique sunlight, and the fruit makes a strong pattern of colour and contrast. Of the four, the pebbles influence the subject most.*

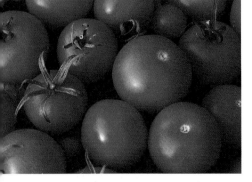

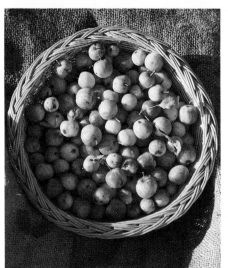

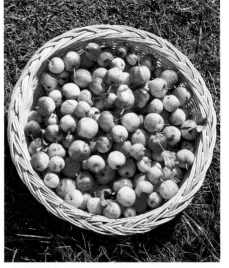

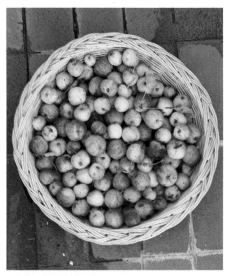

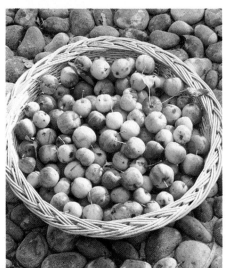

A dark background *(above) has helped to emphasise colour and shape, but the abundance of tomatoes in the lower shot has greater pictorial strength. Fill the frame when arranging such groupings; eliminate backgrounds altogether if they weaken the subject.*

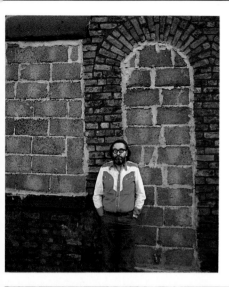

Thematic colour and pattern link subject and background (left) in the shot of the poet Adrian Henri against the wall of the house where he was born. Here the background is integral to the picture, providing scale, mood, and strong composition.

Plain, bold colour dramatises the outline of the girl in the leather costume (right), emphasising her sensual pose. You can provide such backgrounds with the help of studio backing paper, draped sheets, or painted walls.

Supporting detail and texture from a background of tropical plants (below) provide good contrast with the subtle skin tones in this double portrait of two Malay dancers. The area of background is kept small, by close framing.

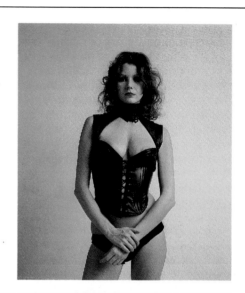

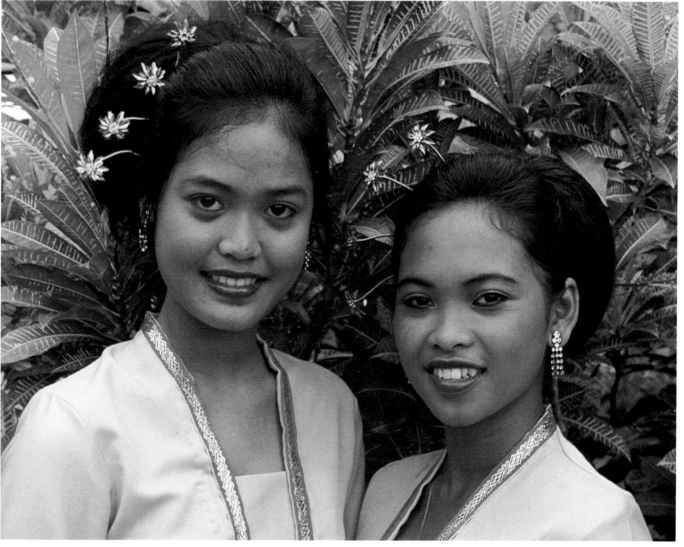

STILL LIFE AND DEFINITION

THE TERM "DEFINITION" refers to the quality of sharp detail and the general clarity of the subject in a photograph. In still life, definition is especially important because you want the viewer's eye to dwell upon the fine detail, the subtle tonal changes, the textures and patterns of light. In studies where there is considerable depth from foreground to background, with a high level of pictorial interest in each plane, good definition throughout the picture is essential.

There are exceptions. Definition also controls emphasis – the main interest in a shot will fall where there is greatest clarity. You may want to emphasise one part of a subject, allowing background or foreground to become an out-of-focus area supporting the main feature. (This selective emphasis can also depend on lighting.)

Obtaining definition depends on accurate focus, a steady camera, and most of all on maximising depth of field. This may not be easy – stopping right down to a small aperture means longer exposures, with the camera supported, and seeing which areas are sharp in your viewfinder may be difficult in dim light.

Potential depth of field extends from the point you focus on, both towards the camera and towards the background. You will waste this potential if you focus on the nearest part of the subject. The trick is to focus on a point about one third of the way in – the "hyperfocal distance" – to maximise the zone of sharp focus in your picture.

Definition and clarity mainly depend on depth of field, especially in close-up. I shot the pictures (right, and below) by focusing at a point about one-third within the required zone of sharpness – the hyperfocal distance.

2 CLOSE-UP

PHOTOGRAPHS IN CLOSE-UP isolate details from the surroundings, creating images of considerable impact and often relentless clarity. The feeling of depth, the composition, and the recording of colour, texture and light are all strengthened when the lens is close to the subject – a detail blown up from a more general view is not nearly so convincing.

Close-up shots lose depth of field as the distance between lens and subject narrows. As you move in close, focusing becomes critical, and you need to stop the aperture down to get depth and definition. This means that you also need a great deal of light, or alternatively long exposures with the camera on a tripod.

Macro-lenses are specially made for close-up work, and focus close enough to give life-size images. For 35mm the focal lengths available are 50mm and 100mm: I prefer to use 100mm, which allows greater definition and depth at wider apertures. To get closer still, you can fit extension rings, usually sold as a set of three, between camera and lens. Or you can fit a bellows unit, which gives greater ability to vary the size of the images, with a continuous range of adjustment.

Clarity, depth and a lens-to-subject intimacy distinguish these close-up shots from mere blown-up details. You will generally need a tripod to give the long exposures required for extreme close-ups.

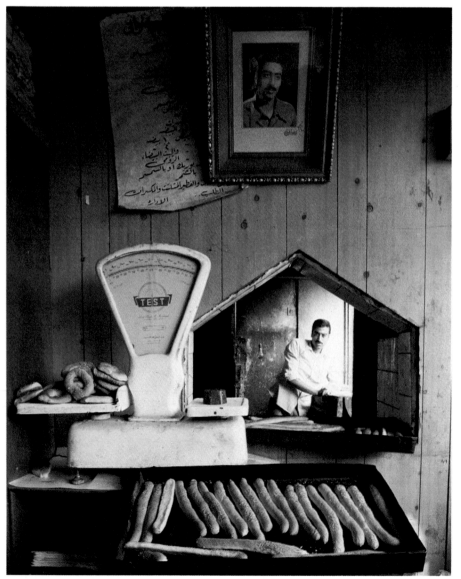

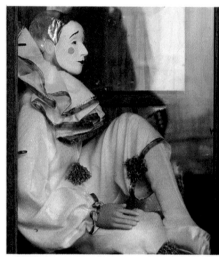

AVAILABLE LIGHT

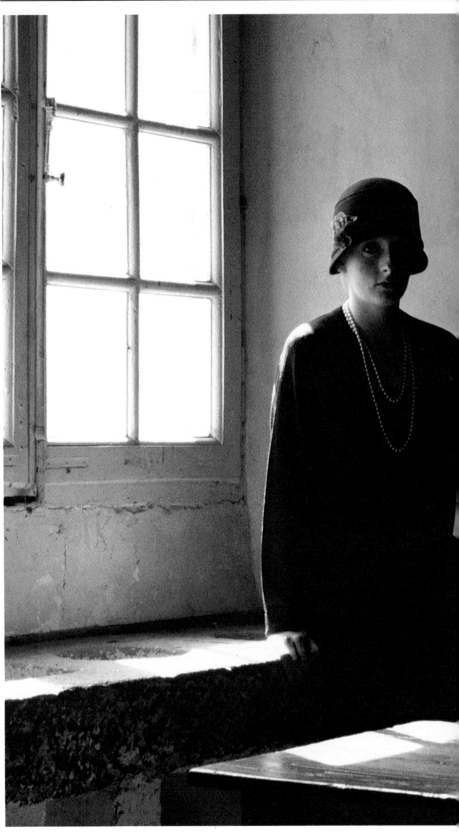

EXISTING LOW-LEVEL ILLU-MINATION, through a window, or from a domestic lamp, or even from street lights, gives a certain aesthetic appeal to pictures – an inheritance per-haps from the early days of photo-reportage when photographers such as Erich Salomon used available light in interiors for candid shots of people.

Diffused daylight indoors can give a softness and wonderful tonal quality to a picture, especially in black and white. The sharp fall-off of light levels away from the source produces considerable contrast between, say, the light as it streams through a window, and the dark shadows where illumination is weakest. Colour rendering under avail-able light becomes subtle and muted, and any colour casts serve to emphasise mood and atmosphere.

Available light pictures are often characterised by lack of depth of field, or slight "shake" or blurring, owing to the need for wide apertures and/or slow shutter speeds in the weak illumination. The answer is, of course, to use a tripod and give longer exposures, with nar-rower apertures. Exposures may need to be slightly longer than indicated by your meter.

Light through windows *gives depth to a picture (below), and a fine range of tones. Reading exposure from the light areas gives dark shadows (right); reading for dark areas gives brighter mid-tones and highlights.*

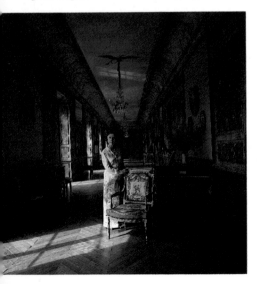

CONVEYING MOOD

A PICTURE CAN CONVEY "MOOD" to the viewer by many different means: the subject matter, the colour composition, the setting, the detail and depth within the scene, and the lighting, all affect our perception, conveying romance or drama, gentleness or mystery.

Simplicity is the key to many successful mood photographs – in choice and presentation of subject matter, in composition, lighting and colour. Soft lighting, as well as evoking tranquillity, will reproduce depth and detail, so that the eye is led to discover things perhaps passed over at first glance. Look carefully and you notice the jewel-like raindrops on the blue hydrangeas (far right), the rustic scene on the vase, the highlights on the glaze. The predominant blueness of the subject is offset by the single accent of pale green in the cluster of flowers.

This picture, and the shots of the unmade bed, and of the lemons, stir the imagination with their very simple approach, their limited harmonious colours, and restrained lighting. The mood is heightened by good depth of field – long exposures were required, the camera mounted on a tripod.

For outdoor photography, let the moods of the weather, or the early morning light, determine the style of your pictures. You may have to wait for a change in the light, a "message" in terms of mystery and romance.

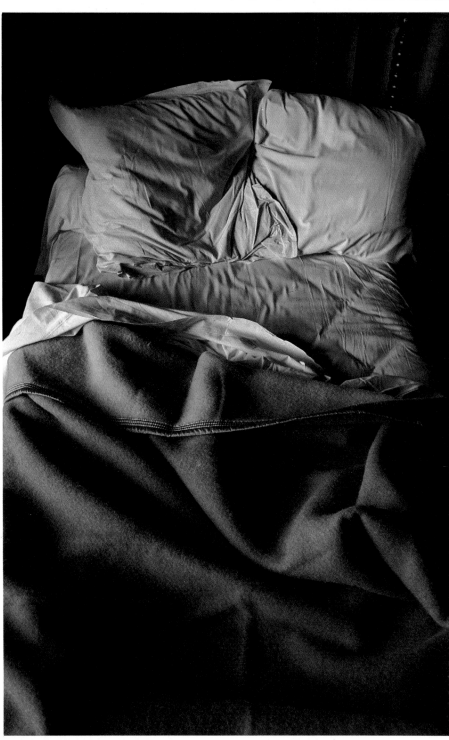

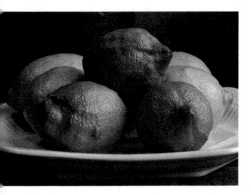

Lemons in the style of the French painter Chardin (above), lit by weak daylight, have that timeless quality that implies a more reflective way of life. The mood is peaceful and soothing. A reflector, to the left of the group, has given detail to the shadows.

An introspective mood, and a nice balance of warm and cool colours and textures, well convey the sleepy, yawning hours of early morning (above). The shot needed a fairly long exposure to obtain a good depth of field in the weak, diffused daylight.

Simplicity and nostalgia (right) are helped by soft lighting and a restful colour theme in this shot of flowers in a country cottage. Texture, pattern and form all conspire to support the tranquil mood – as do the touches of fine detail, particularly the raindrops.

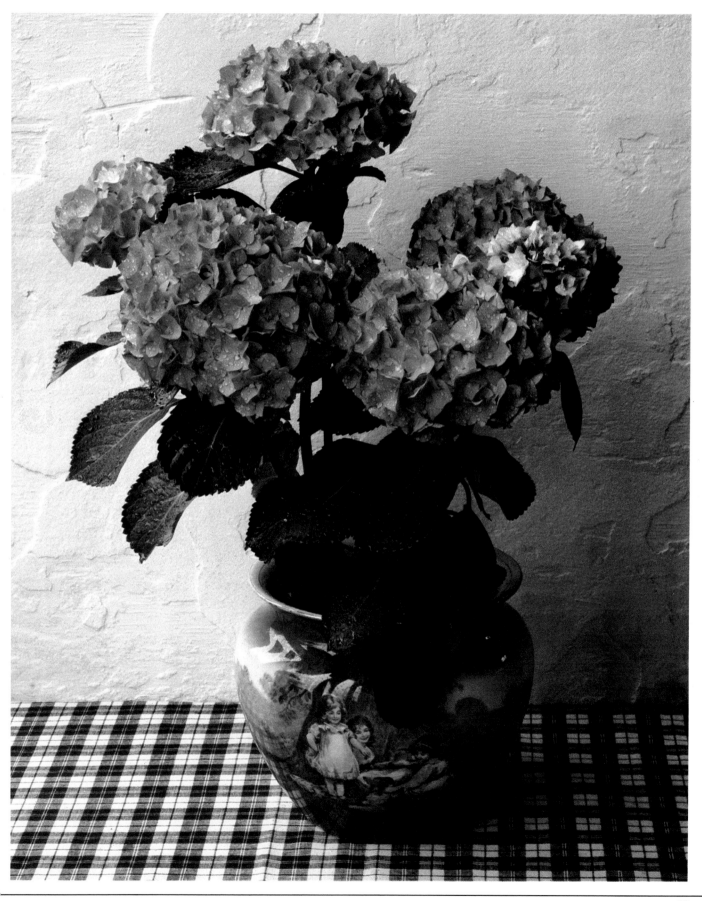

ATMOSPHERE

EARLY LANDSCAPE PHOTO-GRAPHERS sought to imitate landscape artists, recognising that mood and atmosphere are as important in a photograph as in a painting. In their pursuit of an individual portrayal of nature, these pioneers travelled with their bulky cameras, often to barely accessible places, to capture the breadth and grandeur of the great outdoors.

This determined approach is no less important today. I am not suggesting you must climb Mont Blanc to get inspiring pictures. But I do suggest that to photograph any landscape well, even a simple view of fields and trees, does take some preparation. You have to be aware of the influences that will profoundly affect your photography, and plan accordingly.

THE EVER-CHANGING CHAR-ACTER of natural scenery depends primarily, of course, on the light. A landscape is transformed by different weather, season or time of day – shadows, contours, colours and scale alter dramatically, sometimes minute by minute in changeable conditions. The atmosphere of landscape relies on light.

Another vital influence is your own emotional response. After all, you chose to photograph a particular view because it inspired you, and this feeling can be conveyed to the viewer as a shared pleasure. But you must have a clear idea of the mood and atmosphere you want to convey, and use composition to support it.

Your individual approach will find expression in what you choose to include and the features that you select for emphasis. It is easy to forget the simple rule that a picture should have a principal point of interest. But a single element that "sets the scene" – a bent tree, a lone building, a shaft of light or a touch of colour – can make all the difference to your photograph.

The breathtaking panorama (right) reveals the beauty of the Spanish Sierra Nevada in the light of mid-morning. The several points of interest, the receding planes, and the atmospheric light, stir the imagination.

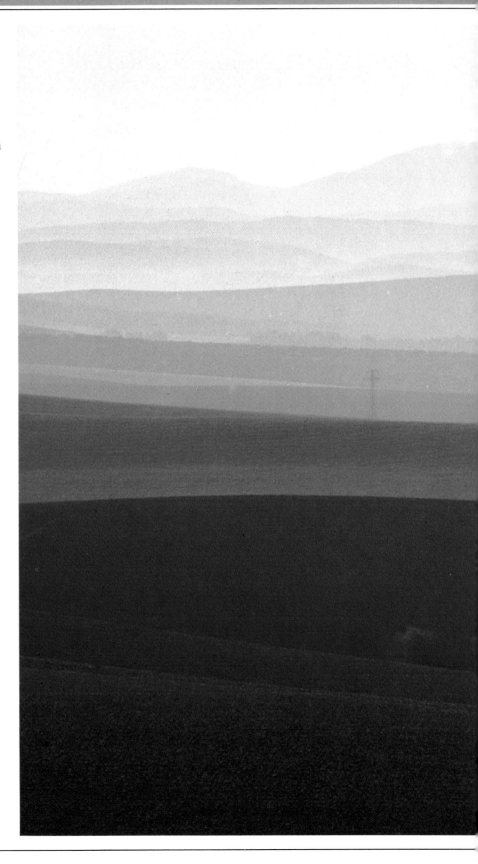

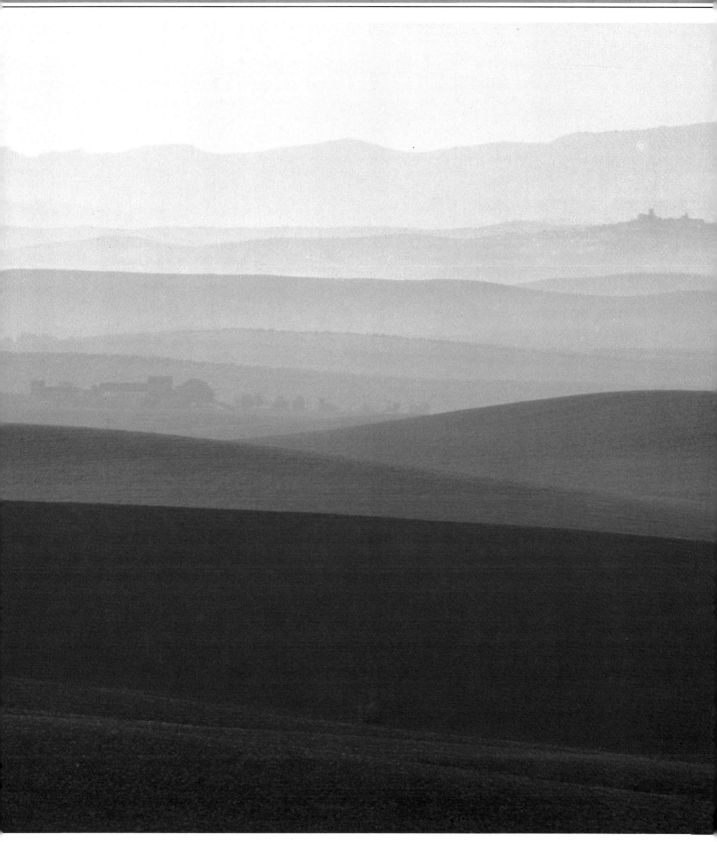

TIME OF DAY

THE COURSE OF THE SUN throughout the day affects the appearance of a landscape greatly, as the pictures below show. The view is of Rio de Janeiro, but virtually any location can display such atmospheric shifts of colour and form, depending of course on the weather.

In the early hours, after the greyish light of dawn, haze mutes colour and bestows a soft, romantic quality on a scene. As the morning begins, trees and buildings cast long, translucent shadows and you will find rich textures where the oblique light rakes over surfaces. By mid-morning the sun is illumi-nating the scene fully, producing warmer colours, greater contrast between light and shade, deeper shadows and sharp detail. As the sun reaches its zenith, the midday light becomes too harsh and direct for good photography, except for rare occasions. The scene is robbed of all atmosphere, and everything appears flat and static.

During the afternoon, form and detail return to the landscape, as the sun moves around to cast shadows in a new direction, and the light grows softer. Towards evening, while shadows lengthen and the sun starts to sink, the scenery takes on a warm, golden glow.

ATMOSPHERE AND IMAGERY in a photograph depend greatly on picking the right time of day for the subject. The picture of the lone rider and camel, on the facing page, was shot an hour after dawn. Haze has diffused the normally harsh sunlight of this desert setting, producing a delicate range of tones, and turning the Great Pyramid of Giza into a mysterious, shadowy form.

If there is too much haze, a UV filter will help, while glare can be dispelled with a polarizing filter. But you will usually get a better shot if you wait patiently for the right light.

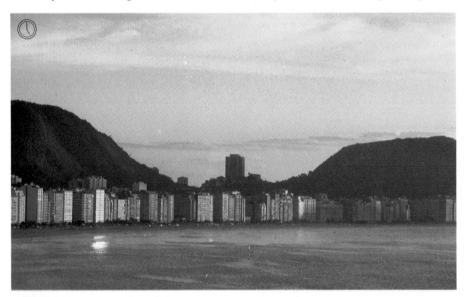

Copacabana Beach, Rio de Janeiro, was photographed looking north from dawn until sunset. The colour and quality of the light alter from a yellowish-green tone following the dawn, to the blue haze of morning, the dif-fused yellow-white of afternoon, and finally the dusky oranges of sunset. As night falls, the detail is only maintained by the artificial lights of the city, and the hills are rendered in sharp silhouette.

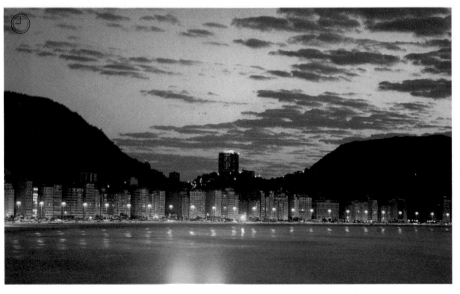

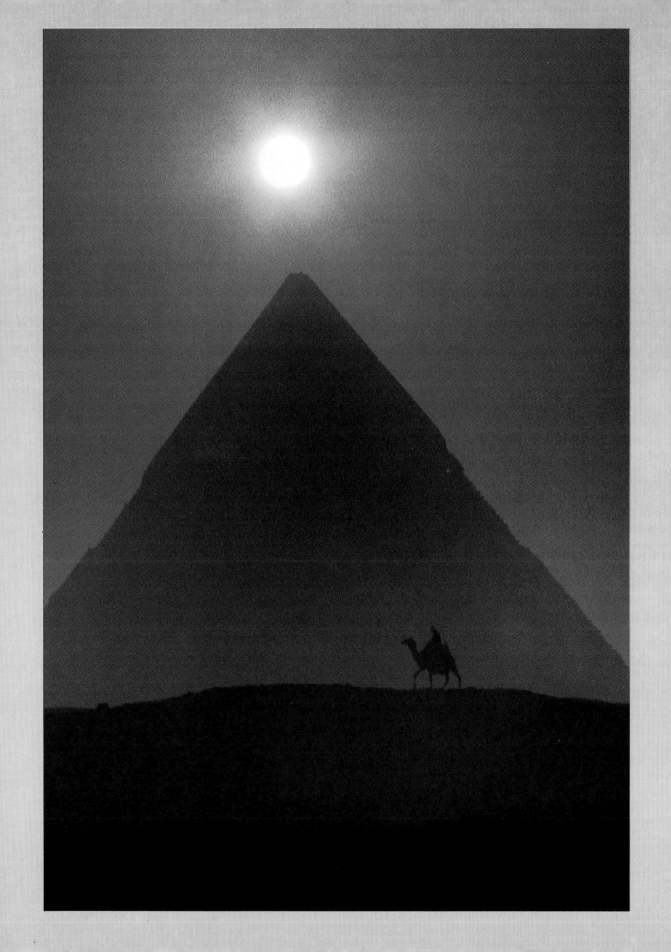

TIME OF DAY: NOON

AT MIDDAY IN SUMMERTIME, with the sun directly over-head, the light becomes almost white, shadows are short and dense, and there is marked tonal contrast. This is generally the worst time for photography. Form and texture are flattened, and reflective glare may dissipate colour, so that landscapes become lifeless and bleached out. People squint in the sun, and their features cast unflattering shadows.

However, harsh, contrasting light may be perfect for capturing the atmosphere of deserted streets, or a glittering sea of azure blue dotted with dazzling white sails.

Unless the sun is diffused by clouds, the light will create strong contrast between highlights and shadows. While your eye can perceive details in shadows, your camera will merely record them as black shapes with little or no depth, because the meter is biased by the light reflected from the brightest areas of the scene, from the sky or from reflective parts of the foreground. Take your reading from the dark areas and your camera will be able to "see" into the shadows, but the rest of the picture will be "burnt out". You can try an exposure somewhere between the two extremes but it may be better to use "fill-in flash" to soften the contrast.

Royal figures and temple animals are an intrinsic element of ancient Egyptian buildings. Such details (above and below) are essential to any photographic essay, and can say more than a shot of the entire site.

The temple at Karnac, near Cairo, is an exception to the general rule of not shooting in the midday sun. A high wall around the monument cuts off the sun's rays during the early morning and late afternoon. I visited the temple several times throughout the day and found that the only effective light was when the sun at noon shone directly down and skimmed the surfaces of the columns, bringing out the hieroglyphs and stone-work in clear relief, as in the close-ups (right).

The single figure at the base of the column (below) was needed to indicate the scale of the building. Because of the strong contrast between light and shade, I took readings for the highlights and shadows, selecting a mean exposure between the two extremes.

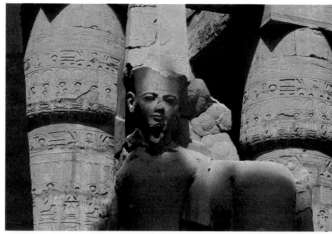

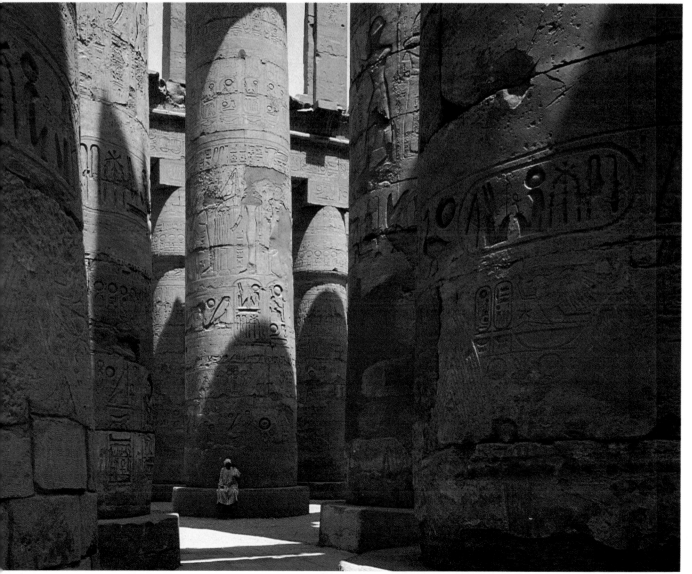

TIME OF DAY: EVENING

T HE LAST HOURS OF THE DAY
are an exciting time for landscape
pictures. In the northern hemisphere
the weather "slows down", and there is
a wonderful, changing light. Clouds
often break, the sky brightens, the wind
drops. Fields and hills glimmer with
reflected colour, and objects form bold
black silhouettes on the sky. As the
colour grows from subtle shades to
vivid red and orange, and then purple,
the light diminishes fast. Keep a con-
stant eye on your meter and don't be
misled by how well you can see – it is
wise to bracket all your shots (that is,
vary exposure by a stop or two).

 If you expose for the dramatic sky,
the landscape will be black. Shooting
the sun itself may halate the film (giving
a halo-like fog) or create flare spots, so
wait until it is behind cloud or a build-
ing, or reddened with haze.

 Dusk pictures are best shot just after
sunset, while some detail remains. You
will need a tripod.

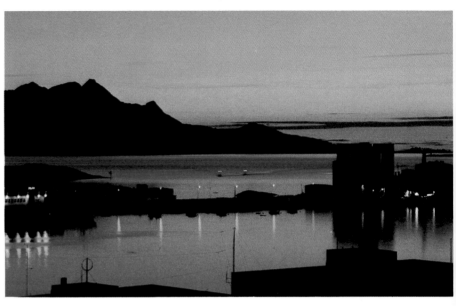

The colours of sunset *illumine nightfall over
Norway, with azure reflections and glowing
pinpoints of light (above). At dusk (below),
detail is disappearing into a flat theatrical
backdrop to the lone figure.*

Sun and sail on the Nile *evoke calmness at
close of day. Shots that include the setting
sun can be made more dramatic with a long-
focus lens which magnifies the orb and dwarfs
distant features of the landscape.*

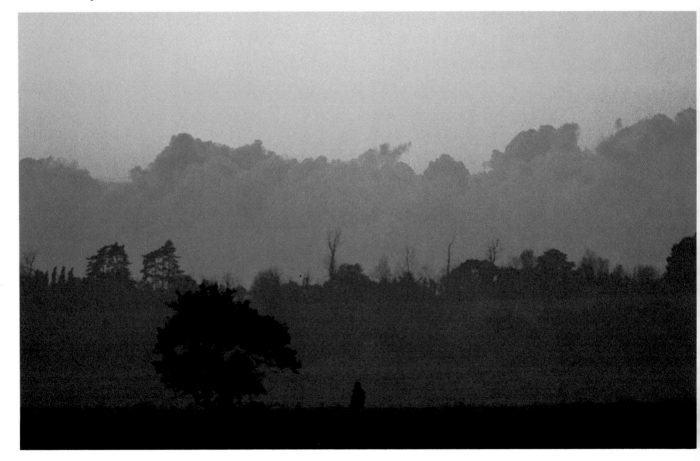

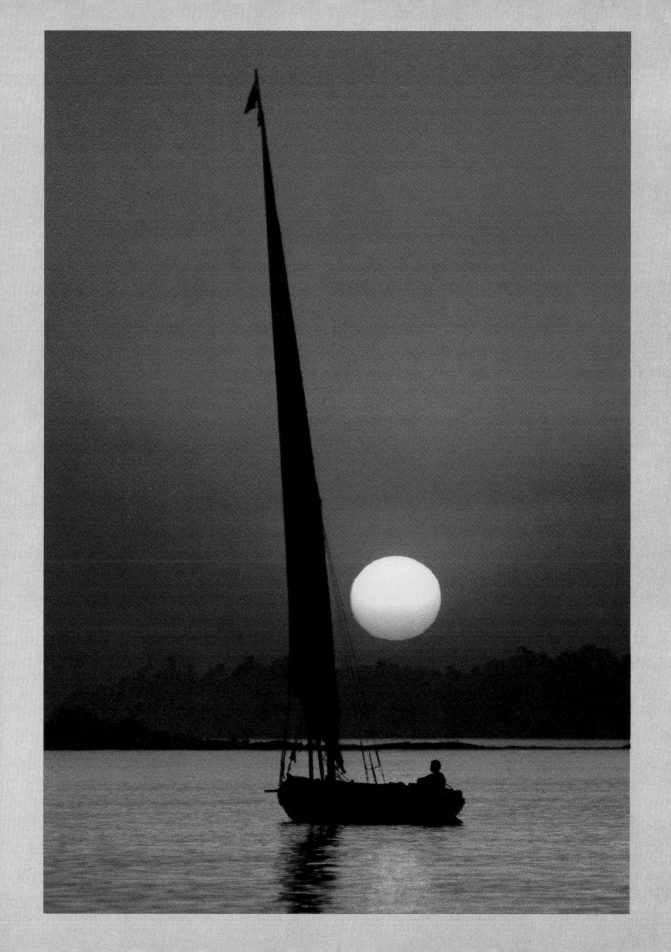

POINTS OF VIEW I

EXPLOITING DIFFERENT
VANTAGE POINTS for land-
scape is important, especially where
there is a prominent feature which can
be related to the surrounding scenery.
As these pictures show, you can alter its
backdrop and setting, and use subordi-
nate features of the landscape to frame
or lend emphasis to the main subject.

Mont St. Michel, in Normandy,
must be one of the most photographed
spots in the world. Its delicate, almost
ethereal atmosphere in the blue light of
winter makes it a 'must' on the itinerary
of any serious tourist. It is a subject
that fairly begs a strong interpretation.

Photograph it from the causeway
that links the island to the mainland at
high tide, and the Mount seems to be
underpinned by tourist buses and cars.
Get any closer to exclude the buses and
its difficult to include the entire gothic

edifice in your lens. The Mount needs
to be related in some way to the sur-
rounding landscape, to the nodding
reed beds, the elegant poplars, the liver-
splotched Normandy cows, or to the
vast spread of sky and sea. It needs a
foreground, middle distance and hori-
zon, with perhaps a bank of white
cumulus clouds, or a summer storm to
provide a dramatic backcloth.

To achieve such effects, you have to
explore the surrounding countryside
for a viewpoint that will give you plenty
of scope and inspiration. The technique
applies to all landscape shots – but it
does demand a lot of tramping around,
crossing muddy fields, clambering over
fences or gates, asking permission of
farmers to take pictures on their
property, and above all, time spent
waiting for the right moment, the most
suitable light.

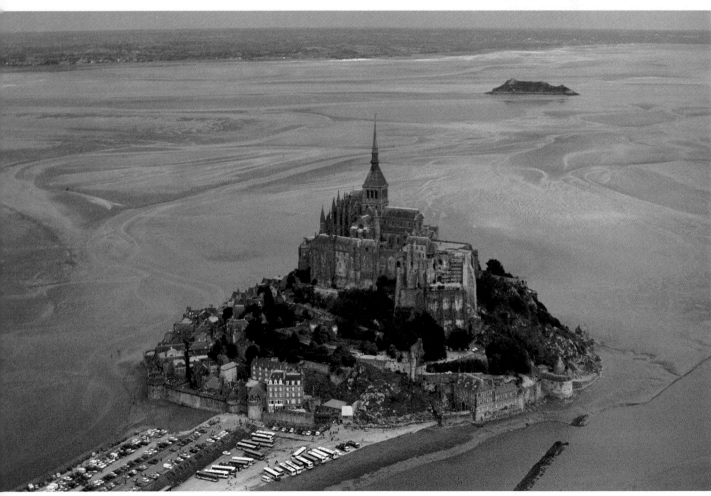

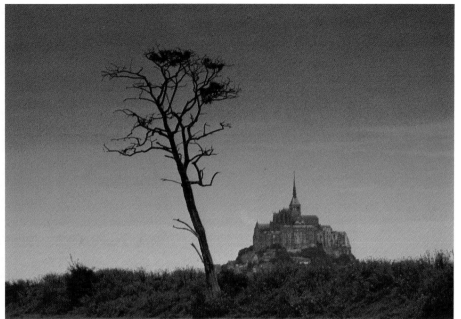

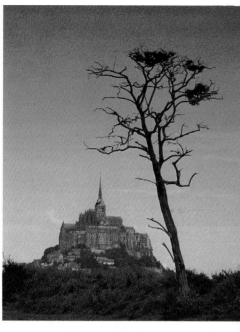

Mont St. Michel *rises above the marshes (above left) and clearly displays its gothic spire and fortified ramparts. Less attractive features are the coach and car park to the right of the Mount, which the lower camera angle hides behind reed beds.*

Changing my viewpoint *(above and above right) gave me these two versions, where the tree adds foreground interest and helps frame the subject. The effect works better in the vertical shot than in the horizontal, where the composition is weakened.*

A Normandy cow *plays her part in two pictorial compositions (below), providing foreground interest. The tree and fence lead the eye to the middle distance and to the horizon. The arrangement in the lower shot is the better of the two.*

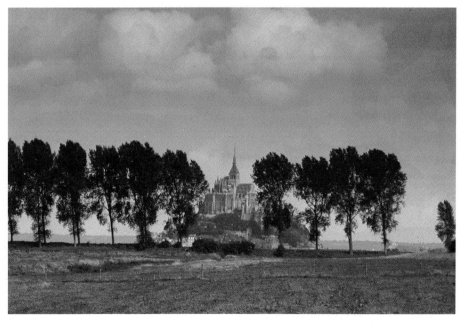

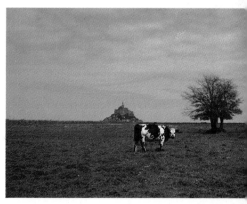

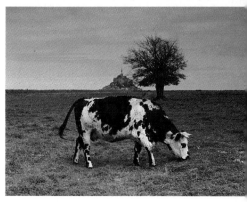

An aeroplane shot *reveals a unique view (left). Tourist trips by plane or helicopter are easy to arrange, and give you arresting pictures. Make the trip at the start of your visit and note suitable vantage points on the ground below.*

A successful 'travel poster' *shot (above) combines many attractive elements – the abbey framed by a break in the poplar trees (a typical feature of the French countryside), delicate lighting, clouds, and depth from the foreground to the blue horizon.*

POINTS OF VIEW II

AN INVENTIVE APPROACH will endow any scene, however lacking in obvious interest, with a fresh vitality and spirit. If you alter your point of view, wait for a change in the weather, select a lens which will frame the subject in a different way, use a filter, adopt an unusual camera angle, or simply shift the emphasis of focus, all the variety of landscape is yours for the taking.

These pictures illustrate the value of such an open-minded approach. I took the first shot, above, in overcast conditions. The result was to be expected – flat, lacking in contrast, with rather dull colours. The view is conventional, and the composition too regular.

Compared to the original, the subsequent pictures have vitality and plenty of pictorial interest. The weather altered dramatically throughout the day, from the brooding, atmospheric effect of a summer storm (below, right), which gives depth and intensifies the greens, to the brilliant, shifting patches of sun and shade. I exploited these moods of weather with changes of view and framing, shooting through wild flowers and fences, and using decorative features such as iron gates and stone walls to relate the church to features in the surrounding country.

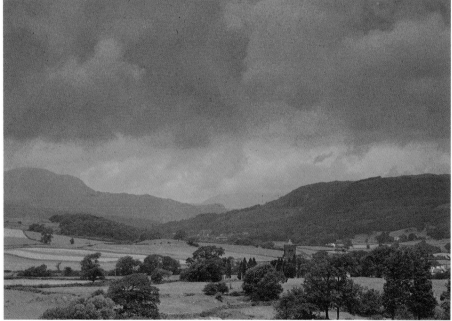

FILTERS

SPECIAL FILTERS, in moderation, are useful to extend control over your subject, and create unusual images. *Diffusing* filters (2, below) soften the image, producing a halo of light; coloured filters (3 and 4) bestow delicate pastel hues to a landscape; *vaseline* (6) smeared over a UV filter gives a foggy, ethereal effect; *graduated* filters (8 and 9) are useful to add colour to skies; a *multi-image* filter (10) splits the image into patterns; a *cross-screen* or "starburst" (11) diffracts rays from highlights; a *colour-spot* filter (12) gives a sharp central image with diffused colour surroundings. (Three of the photographs below – 1, 5 and 7 – were taken without filters, for comparison.)

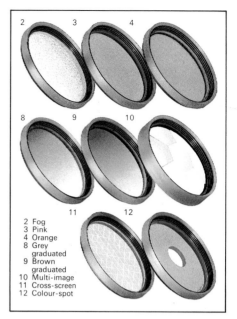

2 Fog
3 Pink
4 Orange
8 Grey graduated
9 Brown graduated
10 Multi-image
11 Cross-screen
12 Colour-spot

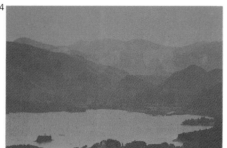

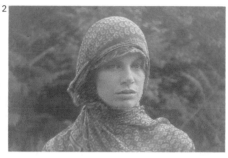

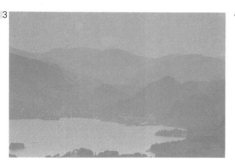

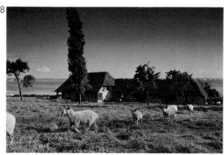

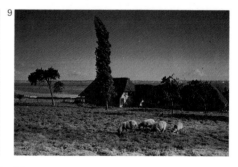

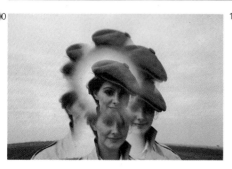

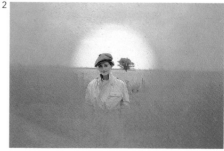

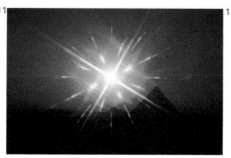

LINEAR AND AERIAL PERSPECTIVE

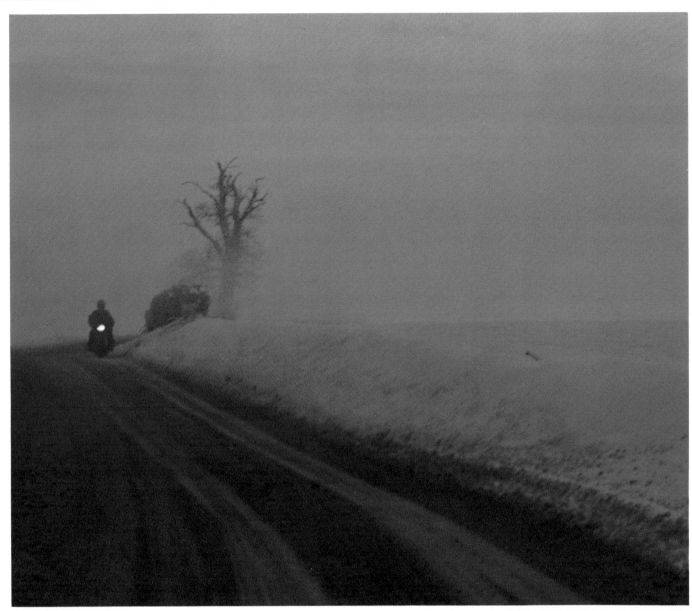

T HE ILLUSION OF DEPTH in your pictures is mainly given by effects of linear and aerial perspective. Linear perspectives makes lines that are parallel in reality appear to converge as they recede, and objects in the scene diminish in size as distance increases. The illusion is illustrated dramatically (right), and more subtly (above, where it also combines with aerial effects).

Aerial perspective occurs when haze or mist in a landscape progressively softens its appearance: more distant objects are lighter in tone and less strongly coloured, and very distant views appear blueish (far right). These colour changes are recorded faithfully by the film, creating a sense of distance. You can often accentuate perspective effects with a low camera angle, or a wide-angle lens, and by keeping some near foreground detail in the picture to emphasise the tonal and size relationship between foreground and horizon.

A wide-angle lens can appear to make clouds recede toward the horizon, particularly those streaky alto-cumulus and nimbo-stratus formations.

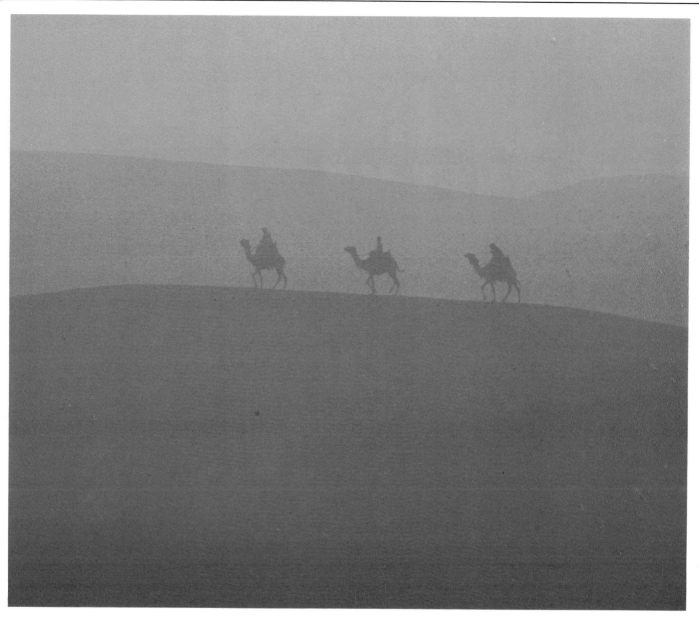

Linear perspective can convey a powerful sense of depth. In the shot of a garden (left) a wide-angle lens has slightly distorted foreground perspective. The motorcycle (above left) is a point of interest in a photograph of ethereal mist which would otherwise lack depth.

Aerial perspective has been created (above) by heat haze, softening sand dunes to flat, receding planes; camels indicate scale. In the landscape (right) the light, haze and contours produce aerial perspective in three planes: the bright foreground, the middle distance, the blue horizon.

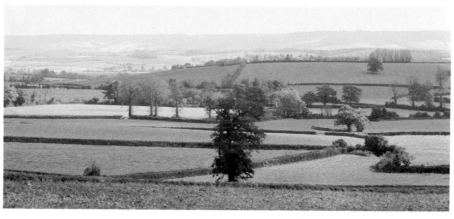

THE SPIRIT OF LANDSCAPE

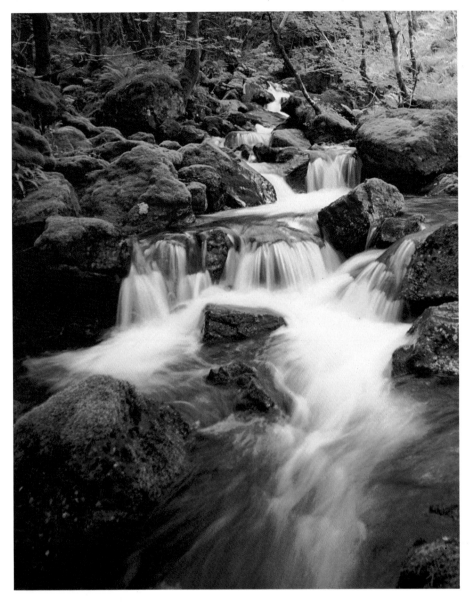

WHEN THE WEATHER PROMISES stormy skies, then is the time to snatch up your camera and go in search of the spirit of the landscape, for nature is rarely static.

Look around you. In flat, low-lying country, the sky tends to dominate, with all its shifts of light and mood. Undulating or hilly landscapes often seem alive with chasing cloud patterns. You may glimpse the sudden, dramatic hues of a rainbow, the flash of a hill stream, or the pearly delicacy of a lake at dawn; or experience the brief, temperamental passage of a summer storm.

These are moments you must be prepared for, and seize instantly.

Watch for marked variations in contrast between brilliant highlights and dark shadows, especially in summertime. Rain can blur, spread, and mute colour to give delicate and softer images, and falling raindrops can be arrested at shutter speeds of 1/125 and over, to create wet-weather effects. A polarising filter can reduce reflective glare from sunlit water or increase the blueness of the sky, while graduated filters will even up the contrast from the sky to the foreground.

Tumbling streams (above left) have great pictorial appeal to photographers. A shutter speed of 1/125 will give an illusion of movement, while 1/500 will "freeze" water solid.

The fugitive spectrum of a rainbow (above) permits a mere half dozen shots. Underexpose by a stop for richer colours.

The placid surface of a Norwegian fjord (right) complements the surrounding countryside and gives a perfect reflection.

A castle at evening (far right), dramatised by a wide-angle lens that spreads the cloud formation with exaggerated perspective.

54

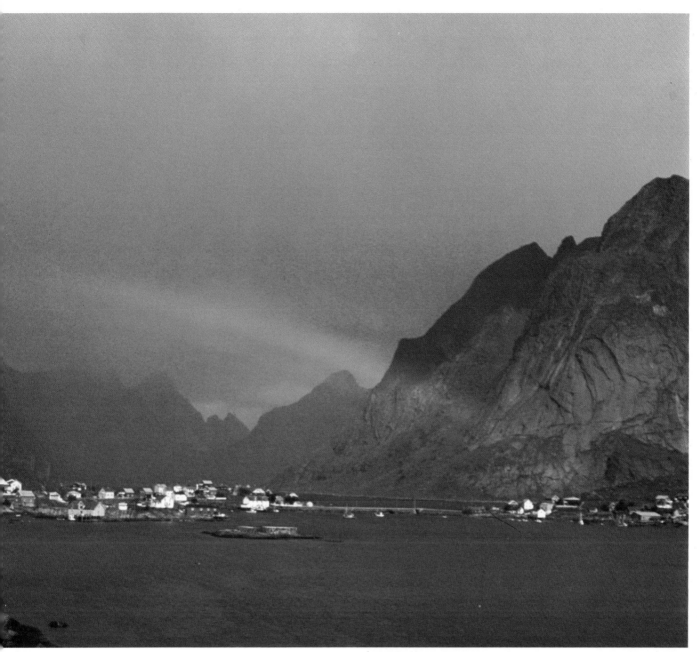

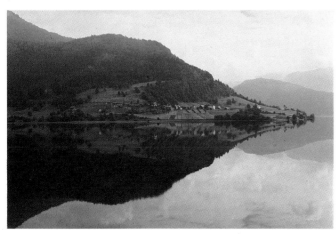

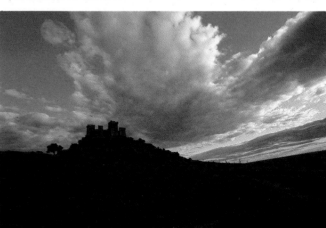

CHANGING SEASONS

PHOTOGRAPHY IS FOR ALL SEASONS – there are few occasions when the weather is too harsh to get pictures. A bleak, lonely cottage at night in wastes of snow provides a picture full of atmosphere – a story, in fact. We can feel how the cold nips our fingers and drives us to seek the warmth within. A gathering storm over the end-of-summer cornfields; a damp mist rising from an autumn river, heralding winter – these images evoke the passing of the year in a memorable way, and you should be encouraged to capture such moments on film.

Snow scenes are hard to judge in terms of exposure, on account of the extreme contrast and reflected light. Camera exposure meters compensate when reading high or low key subjects, so if you want to make the snow look bright and convincing you should take the reading from your hand instead, in the same lighting. As an alternative, *increase* the exposure by one or two stops from that indicated. For example, if your meter reads 1/500 at f16, select a slower shutter speed of 1/250 or 1/125 or a wider aperture at f11 or f8, by overriding the automatic controls.

Wintery weather conditions invariably give the picture a blue-grey colour cast. Using a UV filter will cut haze and produce crisp outlines; and you can even try emphasising the feeling of coldness by shooting on tungsten-balanced film which will turn the scene blue but show lights spilling from windows as a warm, inviting orange.

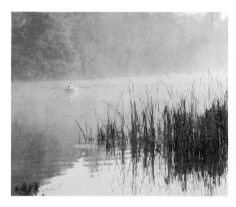

Snow, mist and rain *create wonderful, atmospheric effects. Watch for and catch the delicate autumn mists (above), lonely landscapes swept by lacy patterns of snow (below), or those brief but beautiful summer storms (right), that wash the countryside with sparkling hues of green and gold.*

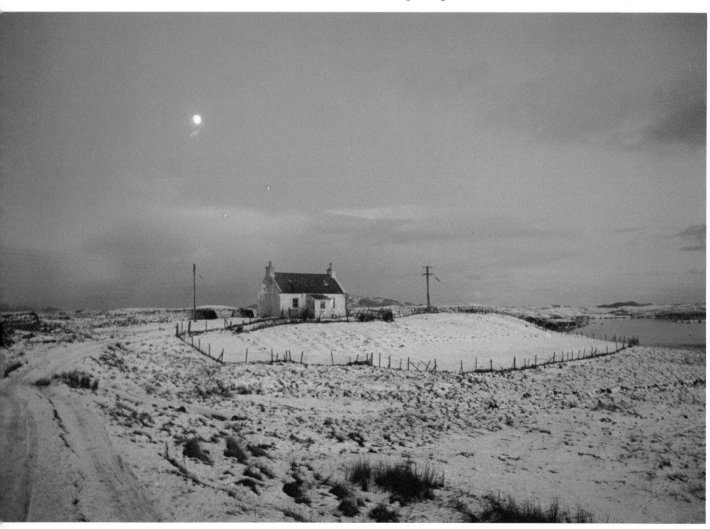

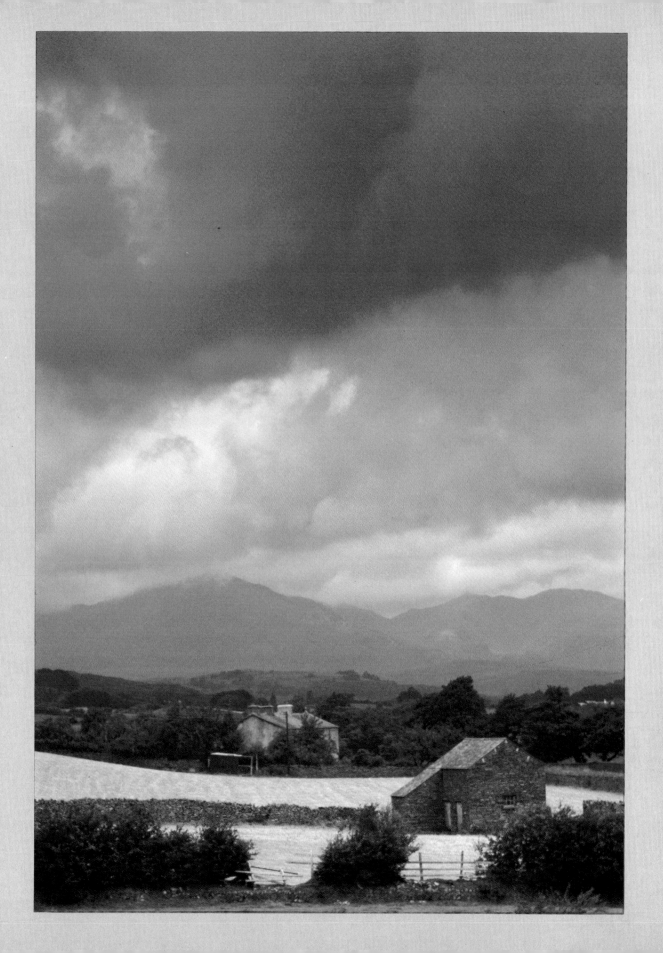

CLOSE-UP ON NATURE

NATURE PHOTOGRAPHY offers an endless source of wonderful images, especially in close-up where you are in a miniature world of brilliant colours, rich textures, strange shapes and patterns, and the often startling yet always fascinating realm of small mammals and insects. Most people begin with shots of flowers. But don't overlook the microcosmic world of lichens and fungi, the tiny star-like flowers of wild grasses and the life on the seashore, in ponds and streams.

A frail, dew-drenched spider's web in the early morning, the gem-like raindrops on the petals of a rose, these are immobile subjects and easier to photograph for the beginner. The problems outlined in "Close-up" (pp 34-35) regarding limited depth of field, which becomes more restricted the closer you focus, can also be used to advantage in nature shots – notice how successfully the frog is isolated from its background.

Generally speaking you will need a tripod and cable release for all nature shots. A macro lens will allow you greater versatility with focusing and quality of image. Diffused, weak or indirect light is usually the best lighting for delicate and fragile nature subjects, or early-morning sunlight (right).

Subjects such as these are likely to be moving, however gentle the breeze, and movement will be particularly noticeable in close-up shots. You can protect them from the wind with a cardboard shield or three-sided box (if you want a plain, uniform background) and a reflector to fill in shadows where needed. Flowers can be supported by wire. With small creatures, such as frogs, you will have to anticipate their actions. Use a fast shutter speed. Moving yourself and your camera in and out to hold the correct focus is quicker, for close-up work, than using the focusing ring on the lens.

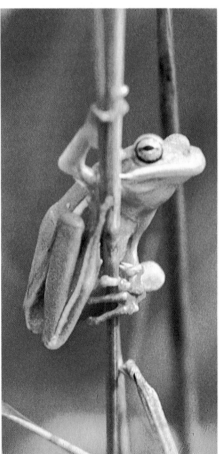

The closer you get, the more you will have to stop down to maintain depth of field. Only a limited area of the rose and frog are in focus, but the hedgerow, photographed further away, has more depth. If you have a fixed lens, or only a standard lens, on your camera, come in as close as possible, then crop away unwanted detail on the final print.

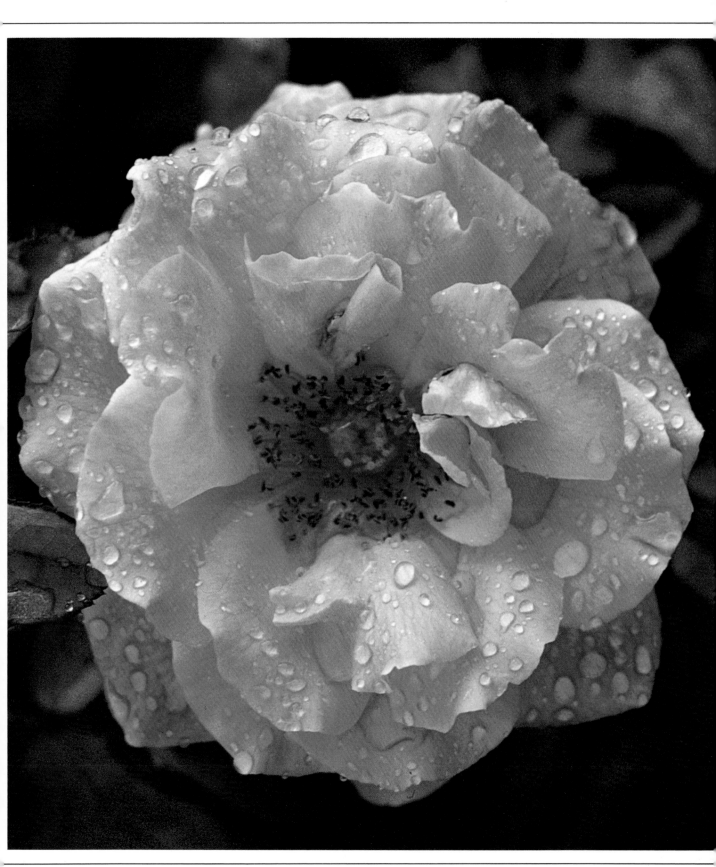

WILDLIFE

WILDLIFE PHOTOGRAPHY is immensely rewarding, but it does need a lot of patience and luck. First essential is to choose the environment. Locating a nest, or the habitual evening foraging spot of a fox, or a kingfisher's flight-path, this is half the battle. And then you may wait many days in a hide to get a lifelike, expressive shot.

I was fortunate in having located an owl-breeding sanctuary, where the ready co-operation of the keepers made my initial task much easier. For wildlife subjects I usually prefer to use existing light and panning techniques (see pp 66-67), unless the subject is too far away, or nocturnal. Here, I photographed the owls in weak daylight, with fill-in flash, and used a 90mm lens.

Longer lenses allow you to get close-ups of distant and elusive subjects; but remember that you have to frame subjects very accurately because of the narrower angle of view, and to focus carefully as depth of field is reduced.

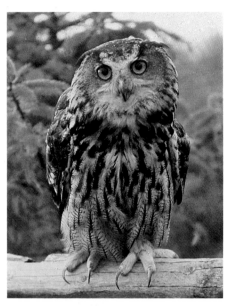

Natural surroundings are essential in good wildlife photography. The importance of context is demonstrated in the studies above and below. A limited depth of field ensures the background won't overpower the subject.

An owl caught by flash (right). The shutter speed for flash (1/125) was slow enough to blur the wings in the weak daylight, conveying movement. The diagram shows where camera, flash and reflector were placed.

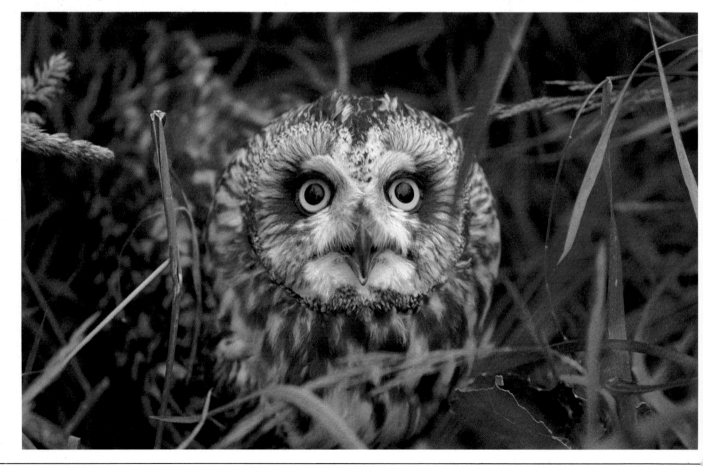

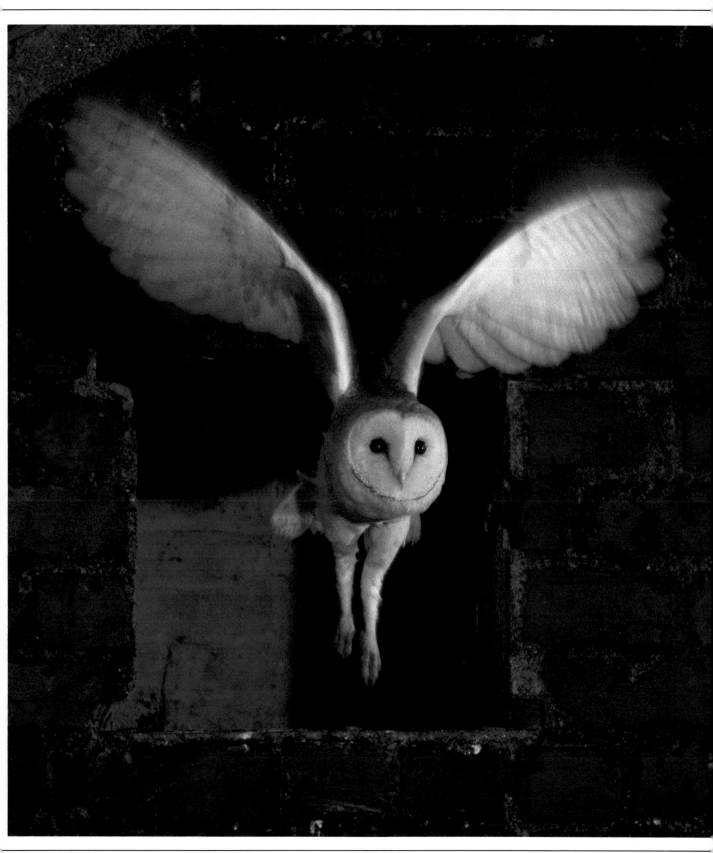

TIMING

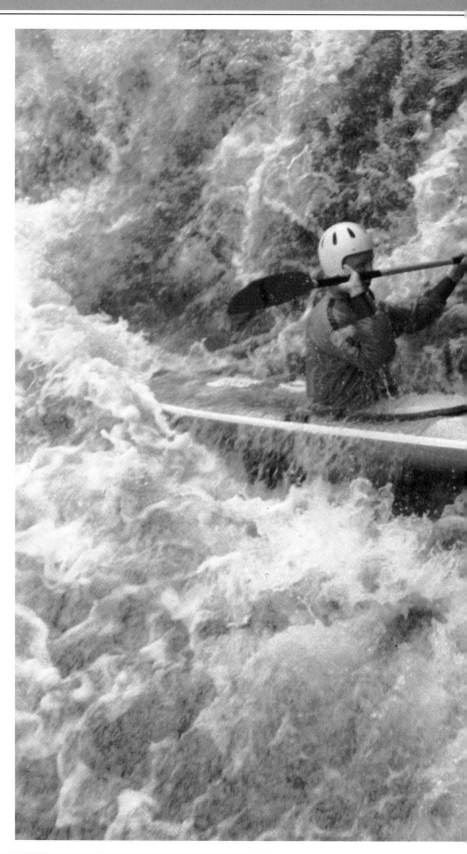

ACTION IN SPORT is usually a continuous dynamic movement, highlit by peaks of effort and drama – as when a sprinter puts out his last burst of speed, or a hurdler leaps the bars like a gazelle. Sport is the essence of practised action, and it is this which your pictures must capture. To do so, you have to prepare well in advance, like the athletes themselves. With sports pictures, you cannot rely on a "lucky break". You may snap away like mad, but somehow your pictures fail to convey the excitement, the force and impetus, the spirit of the event. What has happened is that you have missed the split second that really counts – that vital moment that sums up the very essence of the entire activity.

What then is this vital moment? It varies from sport to sport. It is that fraction of time when the long-distance runner, his arms flung wide, his face distorted with effort and pain, breasts the tape. It is that instant when the bowler has released the ball – not a second before, not a second after.

CONCENTRATE YOUR SENSES, and you will catch that vital moment. Your instinct will anticipate it, your eyes will record it faster than your shutter, your reflexes will respond to catch it on film at the precise instant. Very often the peak of action is clearly revealed on the face of the athlete. You must be close enough to see his expression, but far enough away to show his involvement in the scene, and this may depend on the right choice of lens and viewpoint.

Catching the vital moment depends on being in the right place at the right time, knowing what is going to happen and when it will happen, and having your camera ready, prefocused, with exposure set. Only then can you concentrate totally on that split-second timing that sums up the action at its climax.

A bridge over turbulent water was the best position to shoot this canoeist in action. The climax, here, is when the blade of the oar bites the foam, and the canoe's prow reaches the safety of calmer waters.

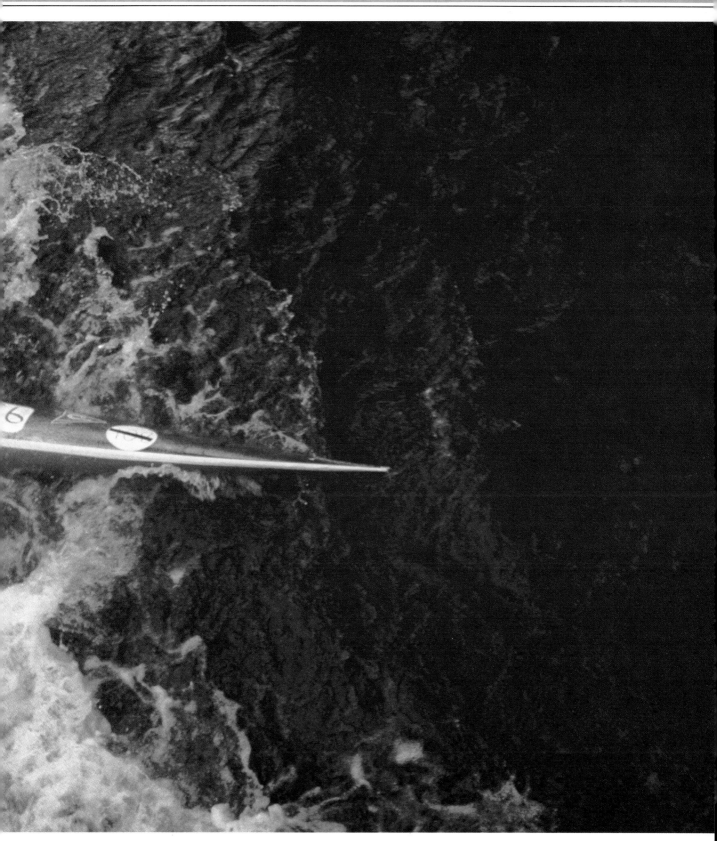

ANTICIPATION

ADVANCE PLANNING is essential for sports pictures. I normally arrange to discuss an event with the performers themselves beforehand, and often ask *them* what they consider a good shot, and why. The answer is usually that the best shot is the one that sums up the activity, in all its clean movement, grace and rhythm – and also its effort and tension. Sometimes, though, unflattering shots can have the most drama, like that moment when a goal-keeper, flying through the air after the ball, misses it by the tips of his fingers – a great sports picture!

CHOOSING YOUR POSITION for shooting, and the related camera angles and viewpoints on the subject, is your first priority. You should familiarize yourself with the sport, the location, and the timing of events. Look for the best vantage points, such as the start or finish line, or a bend in the track, or a point where the peak of energy will meet its prime moment of release.

Picking your sites will allow you then to plan your choice of lenses and camera speeds, and whether to take along your tripod, or a motor drive. *Do* carry lots of film – you can't expect to grab worthwhile action shots with a mere two rolls. Take a selection of slow, medium and fast films, to allow plenty of choice – fast shutter speeds, with small apertures for depth of field, or wide apertures for selective focus to isolate the action.

With a repetitive sport I experiment with a variety of techniques, once I have taken some satisfactory shots – panning, zoom, zoom and pan, flash, flash combined with daylight. This is how you learn!

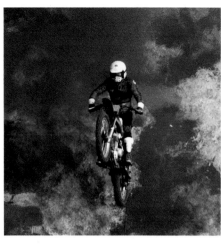

The vital moment *for both athlete and photographer: a second too soon or too late and I would have missed these athletes' dynamic poses, and the motorcyclist bursting out through the flames. This shot, and the hurdler, were taken with a 400mm long-focus lens.*

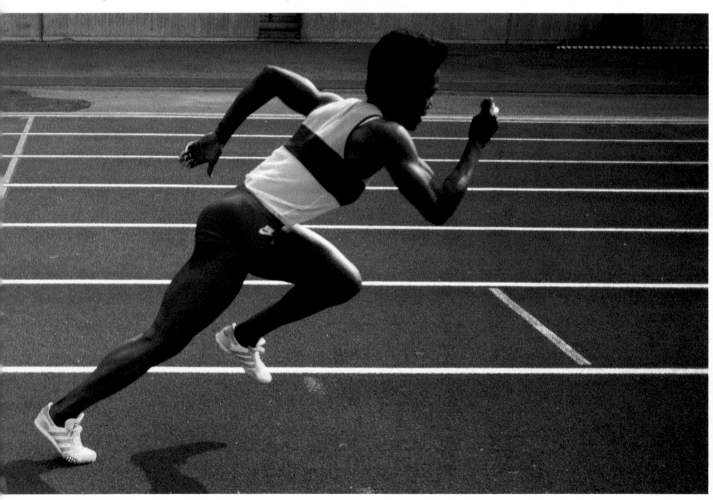

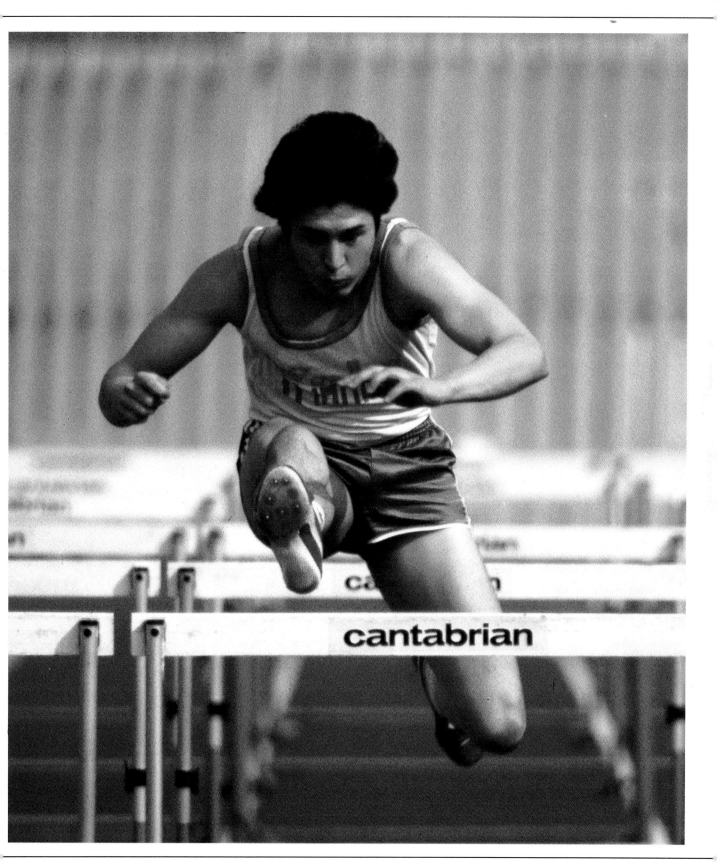

PAN, ZOOM AND FREEZE

PANNING AND ZOOMING are both techniques for conveying speed and dynamism in your subject, by allowing part of the picture to blur or streak as if in movement. With a zoom lens you can even create movement where none exists: focusing the fully extended lens on a static subject and then zooming back during the exposure will produce impressive "speed lines".

Panning is the technique of swinging the camera to follow a moving subject, so that it remains in the frame, as you press the shutter. The trick is to use a shutter speed fast enough to get a sharp image of the subject, but slow enough to blur the background as you swing. The best speed lines result from a background of mixed highlights and shadows. You will create satisfactory blur with speeds up to 1/250 – a good speed for close-range panned shots of

racing cars. A tripod with a pan head is useful for pan or zoom shots, and vital for panning with a long-focus lens.

FREEZING THE ACTION stops all movement, recording the subject in sharp detail. This is quite simple to do – a shutter speed of 1/500 second will catch all but the fastest action. But a frozen shot needs split-second timing or the subject may look static.

If a subject is moving fast across the frame, at close range, you must set the highest speed you have to freeze it, or use flash, or panning. When the motion is oblique, head-on, or further away, the speed can be lower.

When coping with fast action, you run greater risk of camera shake. For hand-held shots, avoid speeds below 1/250 and match speed to focal length – use at least 1/500 for a 400mm lens.

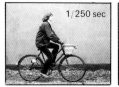 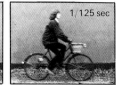
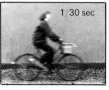

Freezing the action (above)

Panning (below) depends on swinging your body from a firm stance and following through with the subject in your viewfinder, pressing the shutter at the vital moment. Practise, and you will soon be able to pan smoothly. It is important to retain definition of the main subject, using a fast enough speed and sharp focusing.

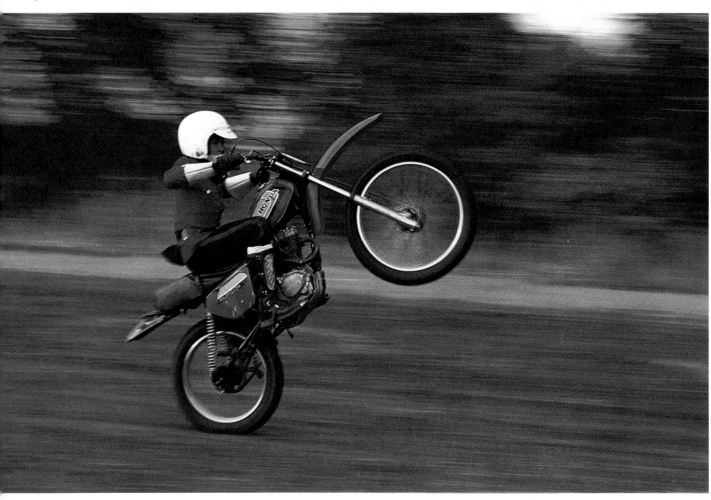

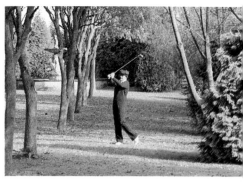

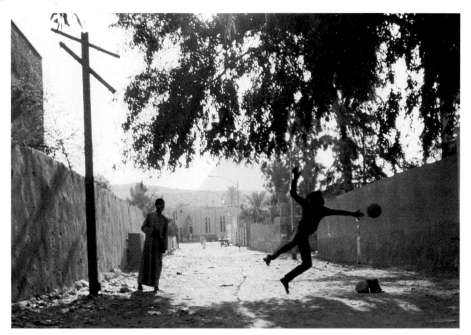

Zooming during exposure can turn a static image such as this golfer in mid-swing (shot with a normal lens, above) into an exciting, dynamic shot (below).

Freezing the motion of boy and ball (left) took a shutter speed of 1/500. The skill lay in the timing of the shot. Using a small aperture, as required by the strong light, also gave me good depth of field.

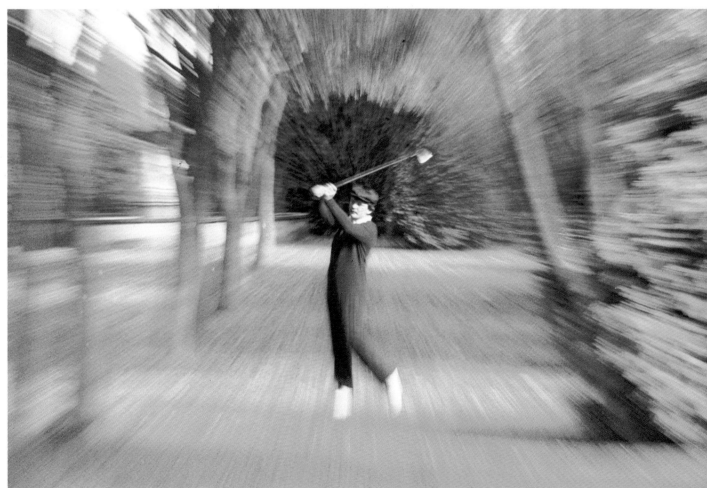

THE DRAMATIC SHOT

AN ELEMENT OF DRAMA should be felt in any sports picture, but some go a good way further in displaying the skill, daring and often breath-taking achievements of the participants – record breakers, stunt riders, mountaineers, even free-fall sky-divers. Camera position and angle of view are critical for such shots. Can the motor cyclist (below) reach the end of his flight before he crashes down on his crouching colleagues? Had I taken the shot a split-second later the picture would have lost its drama.

In order to capture this sort of image you will have to get permission to stand adjacent to the danger spot – under the cyclist (right) or in his path (far right). You will not be allowed to get in the way of the participants, but at least you can select the most advantageous position and use perhaps a long lens, or

even a remote control device. Tell the participants exactly what you want and plan your strategy well in advance. Keep in mind possible directions of light, changes of weather, and whether spectators might obscure your view. Dramatic action shots rarely come by accident: they result from skill, under-standing, and positioning.

MOTOR-DRIVE UNITS on cameras, or the marginally slower autowinders, can be useful but are by no means infallible. Even at between five and nine frames per second, you can miss the vital moment. What the motor drive can do is prepare the next frame as fast as possible so you are keyed up for that moment of anticipation. It also helps where remote control devices are employed – I used a long air-release cable for the shot on the far right.

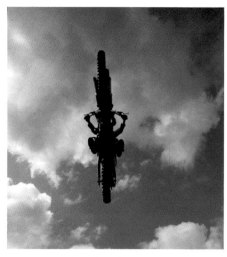

The climax of the Imps' performance, when the senior rider soars over two cars and ten bikes, looks equally spectacular from below or from a more orthodox position among the spectators.

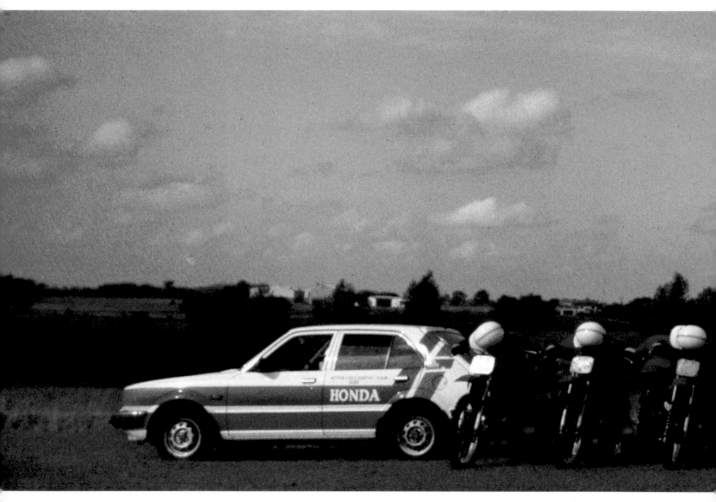

The motor-drive attachment clips on your camera. It is battery-powered and winds on after each shot, at several frames per second. A bulk loader is a useful extra for fast action work.

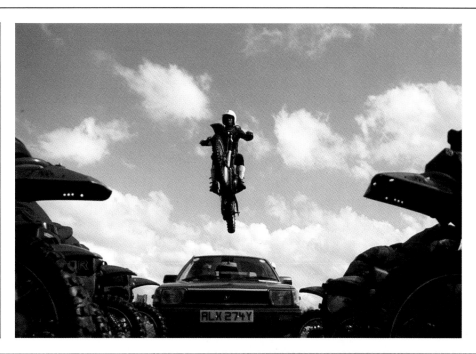

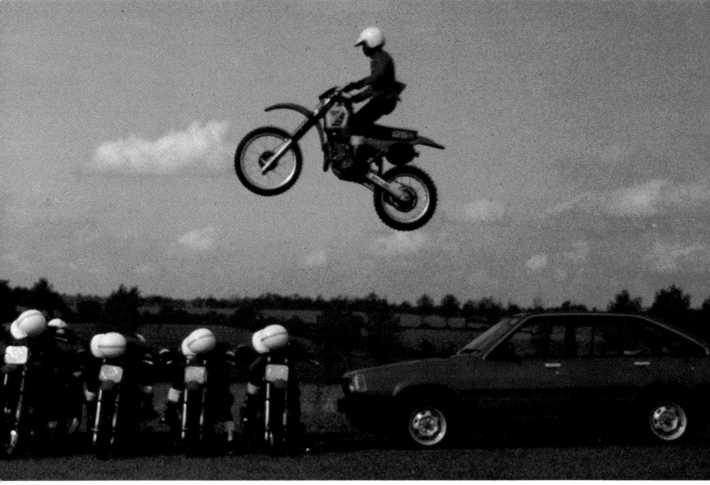

WATCH THE CROWD

THRILLING MOMENTS in spectator sports are as evident in the excited responses of the crowd as from the action itself. Candid shots of cheering spectators (right), or impartial judges, jubilant winners and resigned runners-up (below), make telling photographs. Mostly, the watchers will be preoccupied and won't notice your camera, but you have to be quick, and in the right position to anticipate and shoot crowd reactions. A medium long-focus lens will let you home in on a particular emotional face – a lens that a few seconds earlier had captured the exhaustion of a long-distance runner, or the sprinter breasting the tape.

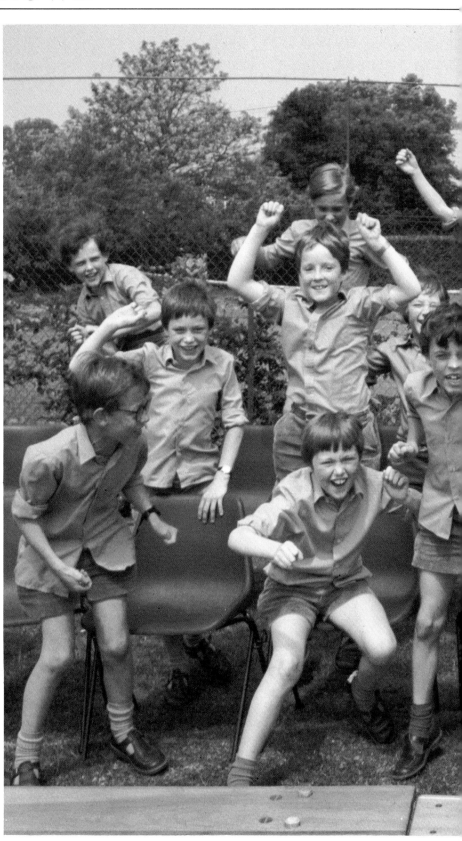

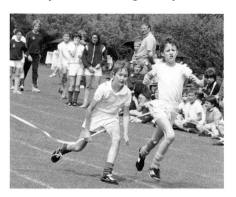

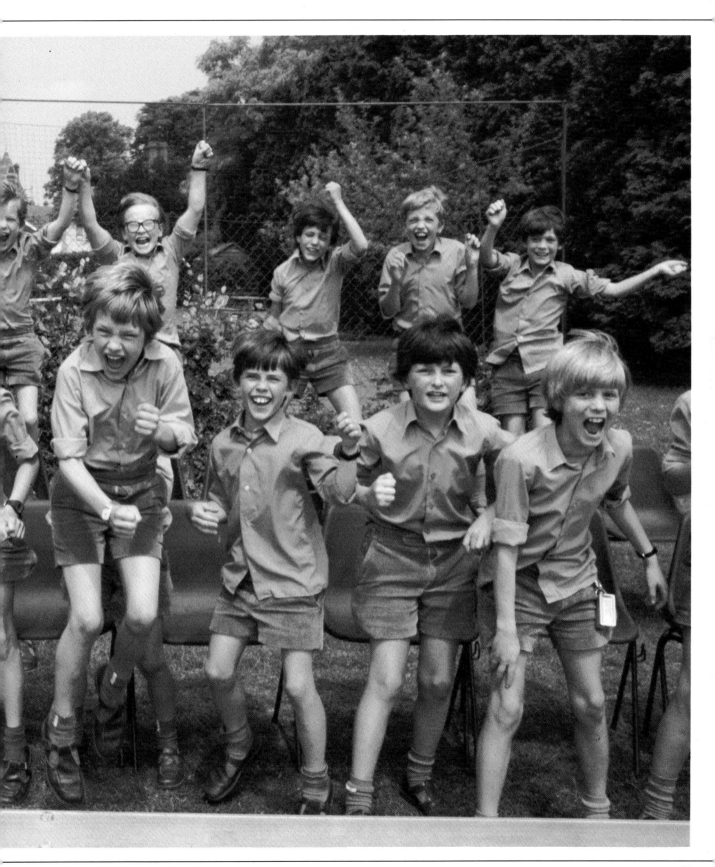

INDOOR ACTION

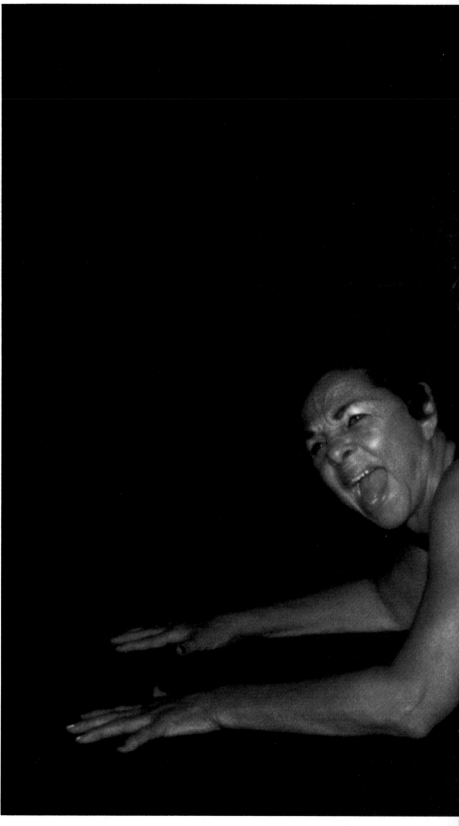

DRAMATIC ACTION SHOTS of wrestlers or boxers need fast shutter speeds and good depth of field because the contestants move so quickly all over the ring – one moment close up, then fifteen to twenty feet away. If you are to capture indoor scenes such as this (right), the existing light may be too low. The best plan is to use a computerised flash attachment, or a camera with built-in computer flash – so long as you can get within flash range of the participants.

The advantage of computer flash is that it leaves you free to concentrate on facial expressions, and the vital moment when a flying body smashes to the floor of the ring, or a hold-down secures a victory. Obviously, you should be as close as you can get, so try for the first few rows of seats and take along a 80mm-90mm medium long-focus lens. You may not be able to avoid including ropes or shadows.

Watch out for those candid shots of the audience, or of wrestlers outside the arena, or weighing in. Don't worry about colour correction with daylight film – the scene is all very theatrical anyway, so that a colour cast will only increase the effect.

Finally, it would be worth your while to take some trial shots at training sessions. Enquire first whether the competitors object, otherwise you may find yourself an unwilling participant!

Flash captures the action *(right) in New York's Madison Square Gardens – the low camera position dramatises the figures.*

Available light sets the mood *(below) and conveys the theatrical glitter of the arena.*

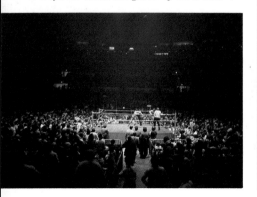

MAGIC MOMENTS

PEOPLE, AS SUBJECTS IN A PHOTOGRAPH, are often far more interesting to the viewer than any other image. The unique capacity of photography is to convey a sense of life in all its aspects. Unposed, informal shots of people in everyday situations are often more satisfying than carefully-posed, set-up portraits.

SUCCESSFUL CANDID SHOTS need good timing, sharp observation and a sense of purpose – the subject may move away, become self-conscious, or refuse to be photographed! Look for backgrounds that will show up the figures, and make a point – and watch for the poses, gestures, or expressions that convey emotion. A medium telephoto lens may help you to keep your distance and select or soften backgrounds. You can respond faster if your camera is preset or on auto control.

 These two pictures needed a minimum of co-operation from the subjects – they were there, naturally related to the environment, and responded more or less spontaneously. It is shots like these that make the magic moments of photography.

American graffiti provide a strong element of design against which the subject (below) adopts an informal and slightly belligerent stance. The couple (right), aware of the camera, take my intrusion good-humouredly.

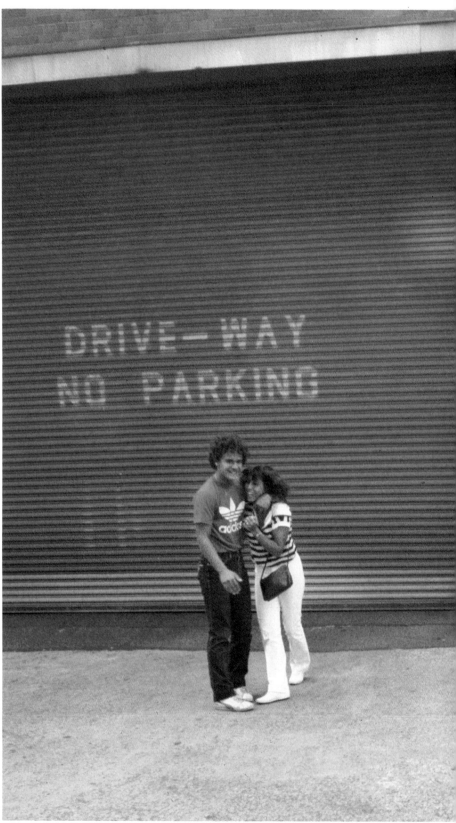

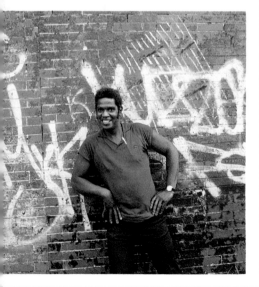

FRAMING THE FIGURE

MAKING A POSITIVE APPROACH to every picture you shoot, especially of people, is very important. Your photograph should make a visual statement, and to do this you must arrange all the salient features so that they are effectively juxtaposed.

Start by making a rapid mental assessment of the variable factors that contribute to the picture. Should you frame horizontally or vertically? What about the quality and direction of the light? Head and shoulders or full figure? How much of the background should you include and where should you place the figure in relation to it? What about the choice of lenses, and the position of the camera? The choices you make will change the emphasis of your picture quite dramatically.

The planning behind a picture is especially critical where you need to relate a figure to visually dominating or impressive surroundings – the figure or group of figures must be able to hold its own. The pyramid shots (far right) are a good example. There is no point in placing emphasis on the pyramid: the entire monument can be taken in at a glance. It is the girl who repays closer scrutiny of the camera, in her expression and her pose, and the powerful orange splash of colour.

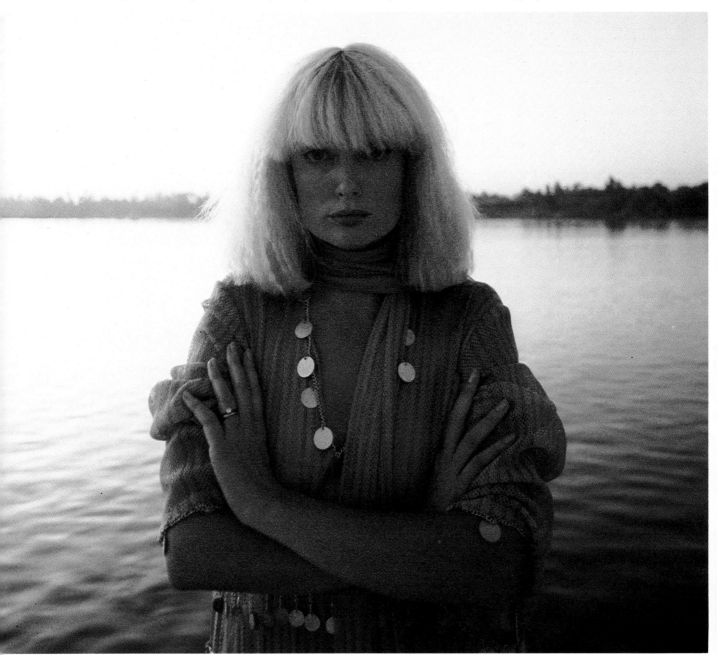

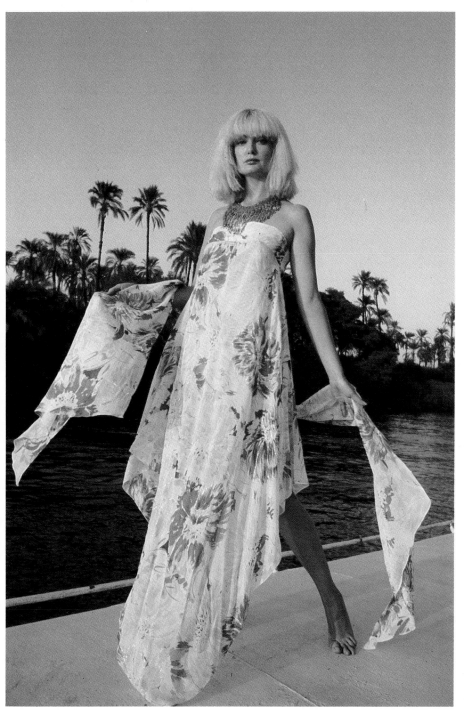

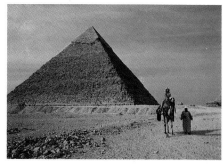

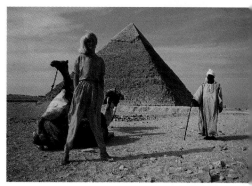

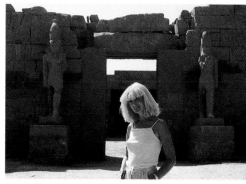

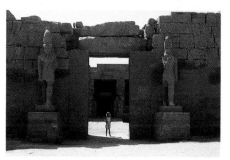

Head and shoulders *against reflected evening light on the Nile (left): I chose a horizontal format, to fill the frame with the figure and still include part of the landscape. The success of this shot lies in the contrast between the highlights and the delicate shadows on the girl's face, creating a serene and gentle mood.*

Vertical framing *and a low camera viewpoint emphasise the elegance of the girl and the long, flowing character of her dress, and set her partly against the sky (above). The summery colours and light, airy atmosphere suggested a fashion-style pose in front of the water and tropical background. Late afternoon sun has created warm, glowing light.*

Bringing a figure well forward *is pictorially stronger. The girl on a camel (top picture) was diminished and unbalanced by the pyramid. The temple doorway (top picture) made a good shot, but the girl seems dwarfed by her surroundings. In bringing her into prominence, interest has shifted to the girl without losing background detail.*

POSES AND LIGHTING I

POSED PORTRAITS, like still-life shots, allow you to exercise fine control of lighting, setting and composition. But portraying a human subject requires social skills, as well as technical. You must help your sitter to relax if you want a "true-to-life" result. Talk to your subjects as you set up your shots, and don't allow them to become tense.

A single source of light should be the principal arrangement for any portrait. This is a fundamental rule, because if you have two main light sources, you will get perplexing and unnatural shadows. The ideal set-up is a single "key" lamp, and a weaker, subordinate one (or a reflector) to one side of your subject, to give sufficient illumination to reveal detail in shadows.

You must then decide whether your subject requires soft and diffused light, or hard direct lighting. Soft light creates a more gentle, romantic effect with delicate modelling, as in the sumptuous portrait (far right), shot in daylight.

Your next consideration must be the setting – do you intend it to be part of the picture, like the tapestry in the portrait, or would you prefer a plain background that doesn't clash with the clothes or detract from the sitter's face and pose? Then there is the pose itself.

A slightly three-quarter turned head is usually a better pose than straight on, but the angle very much depends on the sitter's face. It is usual to emphasise the best features, such as the eyes or lips, or even the shape of the face. If you move in too close, you will get distortion of the image, and make the sitter nervous. A useful technique for close-up shots is to use a 90mm to 130mm lens, which puts you at a distance from the sitter.

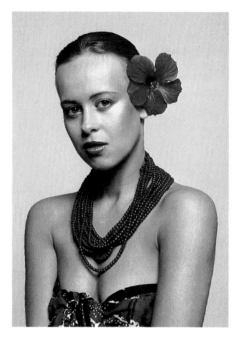

Formal, full-face poses take inspiration from period paintings in style and lighting. The picture above was shot with flash bounced at 45°. The "Lucretia Borgia" picture (right) was shot in diffused daylight, the aperture stopped down for a sharp background.

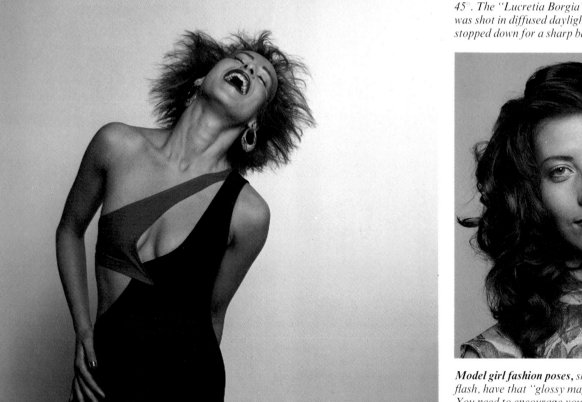

Model girl fashion poses, shot with bounced flash, have that "glossy magazine" quality. You need to encourage your model to respond to the camera in a lively way (left). Use music to get her to dance freely in an area on which you have prefocused.

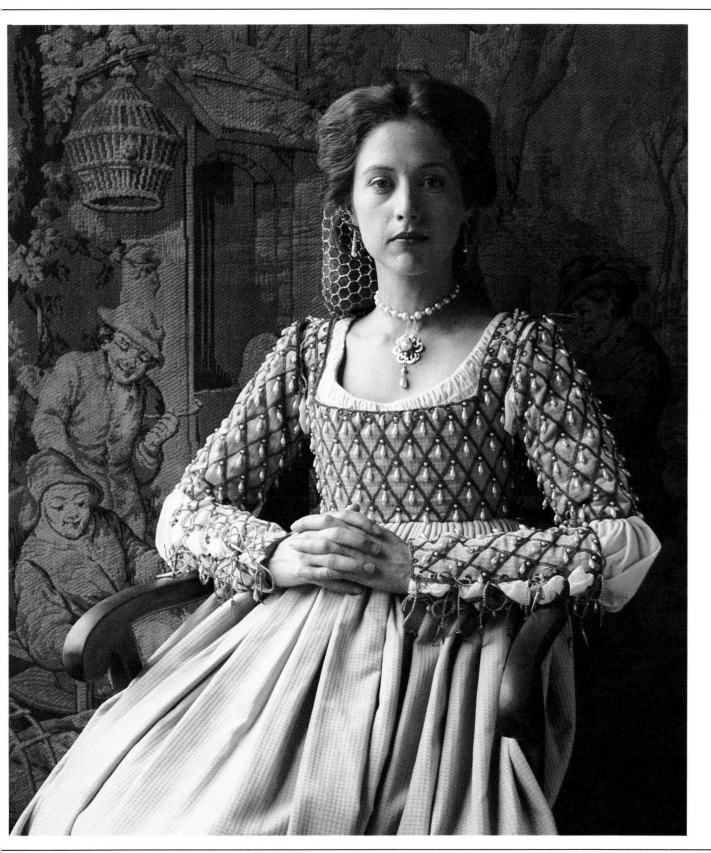

POSES AND LIGHTING II

BASIC YET EFFECTIVE LIGHT-ING arrangements can be set up with plain backgrounds and limited equipment – the pictures on these pages were all shot with not more than three lights, a diffusing screen, and reflectors.

To produce soft lighting you can use one of several methods. Covering the front of your lamp with a material such as tracing paper or thin white cloth will effectively "diffuse" the light (scatter its rays). Or you can "bounce" (reflect) the light off white walls or any sort of screen – a slide projection screen gives a good reflection. Alternatively, use a white sheet pinned to a wall or draped over a door, or a board covered with kitchen foil: a white surface gives a soft light, foil a harsher, blue light.

Some photographic lamps have shallow reflectors and shielded bulbs, and cast the light over a wide area for a softer effect. If you use flash, similar lighting accessories are available, including reflective umbrellas (used by professionals).

Some tungsten lamps have a clamp, so you can attach them to a shelf or bracket; and other lamps can be fitted to simple, collapsible stands (see pp 10-11). Reflecting screens can be moved around to bounce light when you want to fill in shadows.

Although you need time to consider the angles of camera, sitter and the lighting, bear in mind that lamps generate a good deal of heat, and your sitter's discomfort may show in the portrait. One solution, and a useful technique, is to study the modelling while using a lamp, then to shoot with flash from the same position.

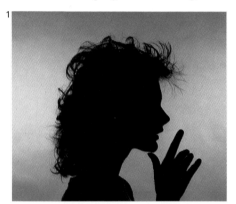

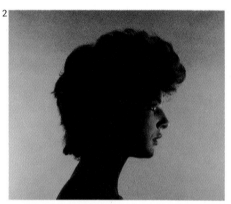

A simple silhouette (left) uses two oblique lights beamed at a background screen, with exposure read for highlights. The stark black shape is relieved by detail.

For a semi-silhouette with some modelling (right), a small spotlight with narrowed beam was placed in front of the sitter's face, but far enough away to soften illumination.

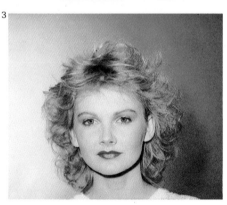

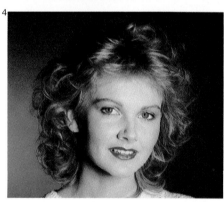

Only one lamp was used (left), the beam diffused through a screen and just off-camera to give frontal lighting. This set-up gave some colour to the background.

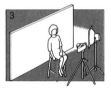

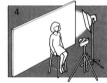

A single light source just right of camera (right) gives slightly more modelling to the features, picks out highlights in the hair, and faintly illuminates background.

The full-face head to waist pose (left) uses two diffused lamps, to illuminate background. A third elevated just right of camera gives modelling and soft shadows.

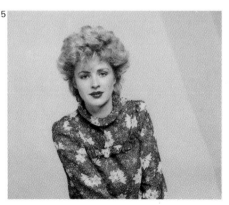

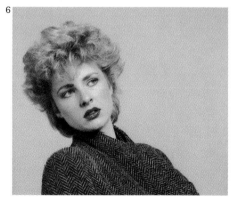

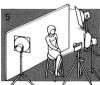

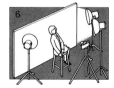

Same girl, same lighting, but a change of pose and costume (right): the change of pose (not the lighting) gives more subtle modelling to her face.

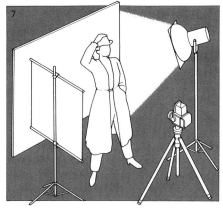

Simple lighting was demanded by the strong shape of pose and stylish hat (right): one diffused lamp, raised next to camera, with a reflector beside it to fill in the shadows.

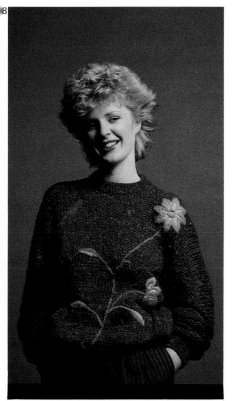

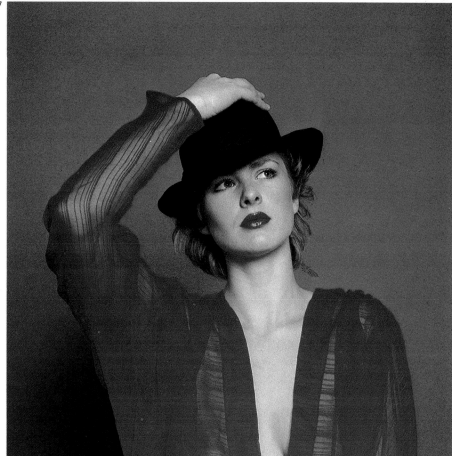

An elevated, single, diffused light at about 45° to the girl, puts part of her face in shadow (left), and enhances the colour and shape of her hair.

 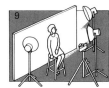

Two oblique background lights, a diffused elevated lamp, and a reflector by the girl's left side, produced this high-key shot (right), with slight over-exposure.

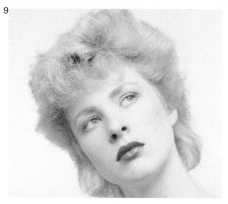

The slightly petulant expression (left) was accentuated by a weak, diffused light, elevated near camera; the background was lit with a single, oblique spot.

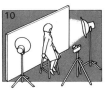 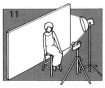

A blue-grey background complements the girl's dress and wistful expression (right). Low-key, slightly elevated lighting was further softened by underexposure.

LIGHTING AND THE NUDE

THE NUDE FIGURE has been a favourite image for the camera since, in its early days, photography followed closely on the heels of fine art. The eye of the camera has dwelt lovingly on the beauty of form and texture, and the way light caresses each subtle curve and falls away into shadow. The nude has become the classic subject for the study of form and lighting technique, but the realism of a photograph invariably conveys sensual and erotic undertones as well.

This sensuality is emphasised when the subject looks directly at the camera; in close-up shots of the body the effect is more depersonalised. You can, of course, introduce an element of the erotic deliberately by the inclusion of a garment or a prop such as a bed or armchair, underlined by the choice of lighting.

AIM FOR SIMPLICITY in choosing your backgrounds and posing the figure, and keep the lighting simple too. It should be soft and directional, using just one light source and a reflector – bounce the light off a white wall or a white sheet pinned to the wall. Move the light around the model as she poses, letting it follow the direction of the form. If she is sitting in a chair, for instance, leaning on her left arm, your light source would be pointing towards the left. The effect of modelling form can be increased if you narrow the beam of light – with a screen, a door, or even two chairs, or by placing your light source outside the room.

Harsh lighting will cast hard-edged, dark shadows, so diffuse the source with tracing paper or muslin. Soft daylight is a sympathetic source for nude photography, but avoid direct sunlight unless it is weak or diffused through a net curtain.

Sensuality and abstract form are the classic qualities of the nude, contrasted in these two photographs. For the standing nude (right) I placed the light source outside the room – the sculptural flow of light and the direct gaze suggest eroticism. I used softer light for the close-up study (far right) to create an interplay of shadow and texture.

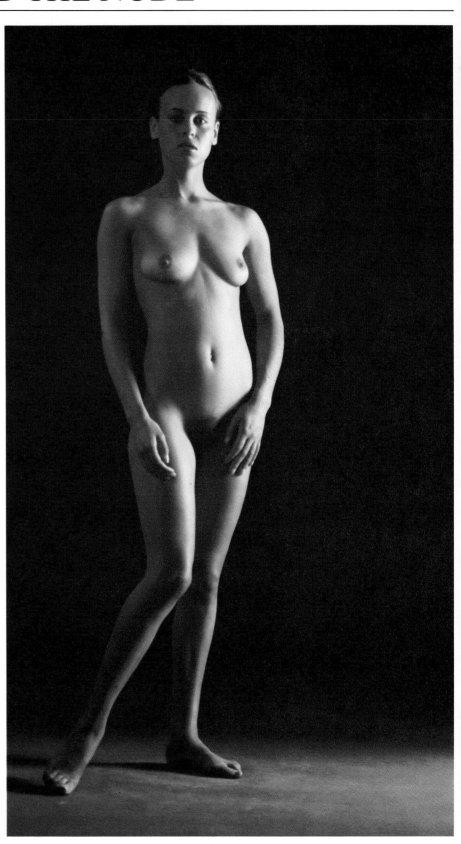

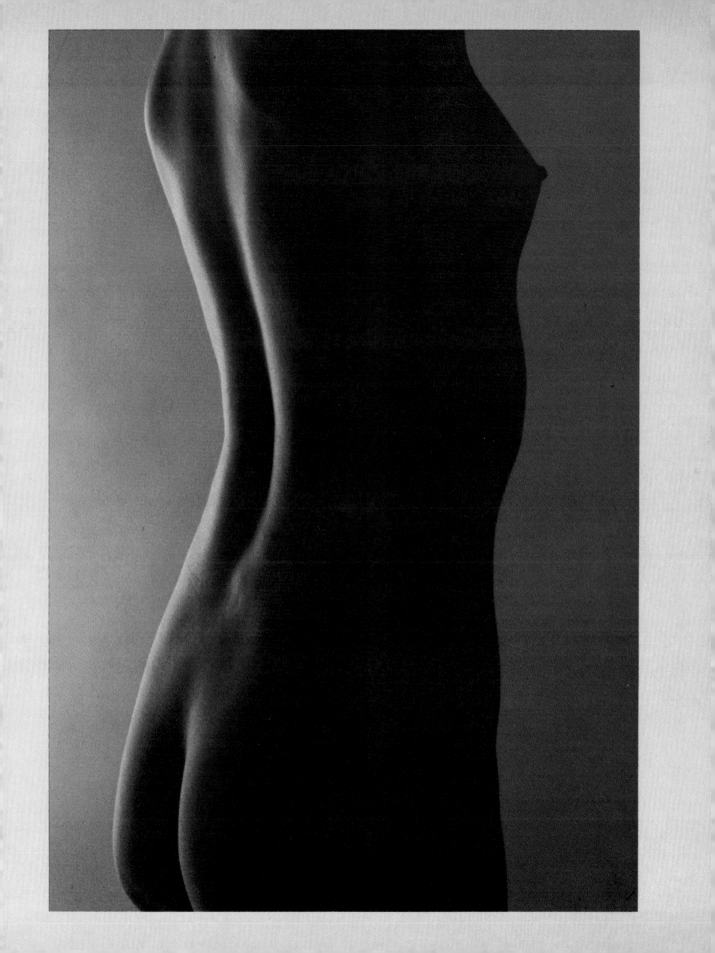

FACES AND PLACES: BACK TO NATURE

OUTDOOR LOCATIONS can greatly enhance the mood and atmosphere of nude photographs. They suggest sensuality, an air of leisure and relaxation the camera is privileged to witness; a long-focus lens will emphasise this feeling of privacy. Added to this is a sense of innocence, a rapport with nature, assisted by the quality of the light.

For this kind of picture to succeed, the model must blend with the setting, and appear unself-conscious.

The girl on the far right is nicely balanced against the ornament in terms of both colour and composition, her body framed by the stone pillar and the ivy. The girl below has an innocent candour; while the girl on the right is more sensual, the glowing, golden quality of her body accentuated by the yellow towel and by the striking hues of the fuchsias.

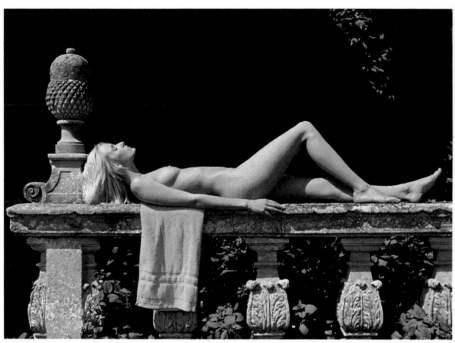

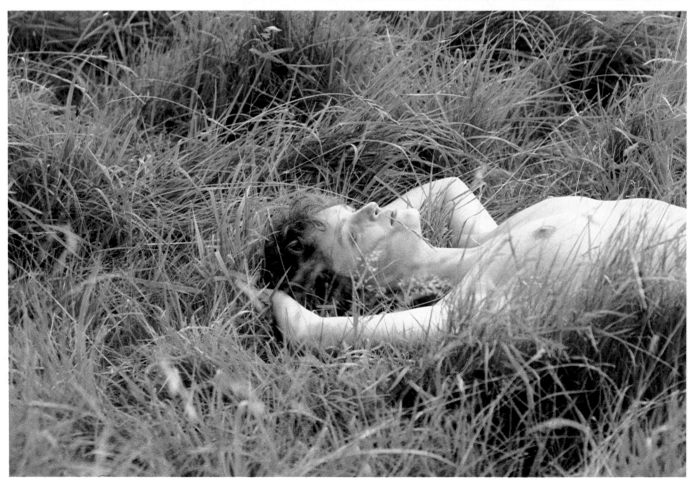

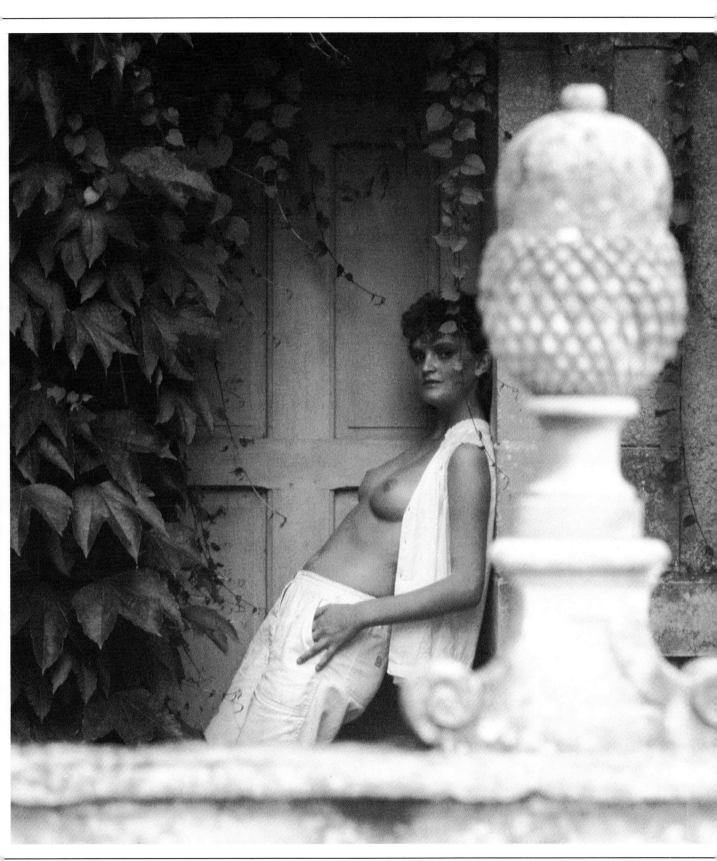

FACES AND PLACES: THE WEDDING

A GREAT OCCASION such as a wedding is no time to take chances – you have to be sure of your shots, especially if you are the sole photographer present. More than with any other photographic assignment, you need to plan ahead and know exactly what you are after.

Weddings usually follow a fairly strict pattern of ceremonial events. As every bride knows, the sun shines, bells ring, choirs are angelic, mothers weep, and the best man pretends to lose the ring. If you are the photographer, you must anticipate each stage of the occasion and be in the right place to get your pictures. Test all your equipment beforehand – two cameras if possible, a tripod, fill-in flash for overpowering sunlight or dull days, a standard, long-focus and wide-angle lens, and plenty of colour print film – you will need to make many copies from the negatives.

Visit the church in advance of *the* day and talk to the vicar or priest; request his permission to shoot (discreetly) during the service, and pick your camera positions and lenses.

Outside the church, note exactly where the sun falls (try and be there at the same time of day) and select a spot where the sun won't shine directly on the subjects' faces and cause them to squint. It is traditional to pose groups in the church doorway, as this setting provides a strong, plain background. But choose an additional position, where you can include the entire church. Take some fast film (400 ASA) for shots in the church, but be sure not to use it all up – you will need to keep ample in reserve for the reception.

BASE YOUR SEQUENCE OF PICTURES on the customary sequence of events at a wedding, beginning with the bride posing in her wedding dress (perhaps a contemplative shot in her dressing room), then the arrival of the guests at church, and of the groom, best man and bridesmaids, and the bride and her father – three minutes late . . .

Shooting the service inside the church you will need a tripod for the fairly long exposures (never use flash, in any circumstances), and perhaps a 135mm long-focus lens. After the sign-ing of the register, the bride and groom process up the main aisle and leave the church. Photograph them in the porch while the best man (your ideal assistant) holds back the guests.

Build your groups now according to status: the best man joins the bride and groom, then the bridesmaids and pages, then parents, close relatives, and finally a big group with all the guests, and perhaps the choir and vicar.

A tripod is useful for shooting groups, but you may prefer hand-held shots when everyone leaves by car for the reception, and the happy couple are showered with confetti and rice.

Receptions provide splendid oppor-tunities to get candid camera shots of speeches, the cutting of the cake, the toasts, jovial relatives – plus some posed, romantic portraits of the bride, and the couple together.

Finally, the going-away allows you to catch those fleeting expressions, furtive tears and snatches of robust humour that make wedding photo-graphy a challenge and the prints a last-ing pleasure.

FACES AND PLACES: THE DANCE HALL

A SINGLE, LINKING FEATURE can give the foundation for a whole series of pictures. I photographed this Hollywood-heyday, thirties-style sofa in London's Camden Palace disco, and asked arrivals to pose. Although the sofa has a strong, fan-like shape, the colours are fairly neutral; so the setting doesn't clash or vie with the inventive, visually arresting fashions.

If you have the time to plan an extended photo-essay over a long period – a season or even an entire year – you will be rewarded with intriguing photographs of, say, a park bench and all who sit on it, or children at a school gate, or the visitors to a famous statue.

You may wish to start with a view from a fixed spot that can be repeated exactly.

If you intend to mount your camera in a selected spot, for the sake of continuity make a note of the tripod position and the lens used, and mark in a notebook the area included in the viewfinder. Or make a print and mark the details. Maintain a simple lighting arrangement in interior shots, and one that is constant throughout. You may be lucky enough to have a regular vantage point for shooting candid pictures of people – at a bus shelter, or in a café window. The voyeuristic element merely emphasises the role photography has always played in recording human emotions and vanities.

WORKING ENVIRONMENTS

PORTRAITS IN THE WORKING SURROUNDINGS of a person have an intriguing extra dimension. You are taking two separate subjects at once – the person and the environment – and arranging a balance between them. Try letting the subject choose the pose: the sculptor Henry Moore (below) and the Egyptian apothecary (right) have adopted natural positions in keeping with their jobs.

Include as much background as you can without overpowering the sitter – select a view that is interesting but not too distracting. A 28mm wide-angle lens will give you a great width of view, and if you keep the sitter in the centre, there will not be too much distortion. Whenever you can, use available light.

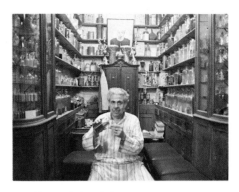

A wide-angle lens helps you to include more of the surroundings, and placing the figure in the centre of the picture avoids periphery image distortion. Moving in close (right) has thrown greater emphasis on the subject. The lines of shelves concentrate interest towards the apothecary's face and hands.

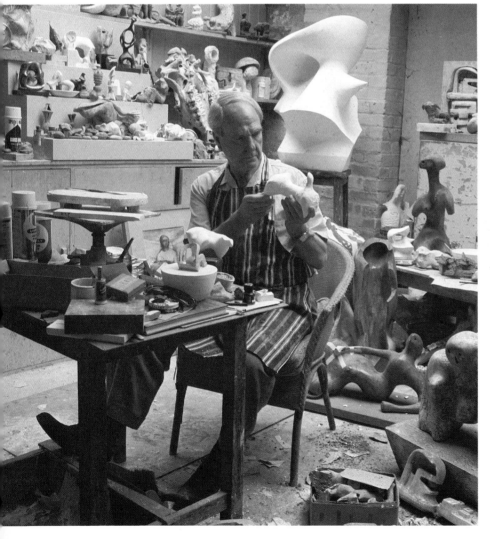

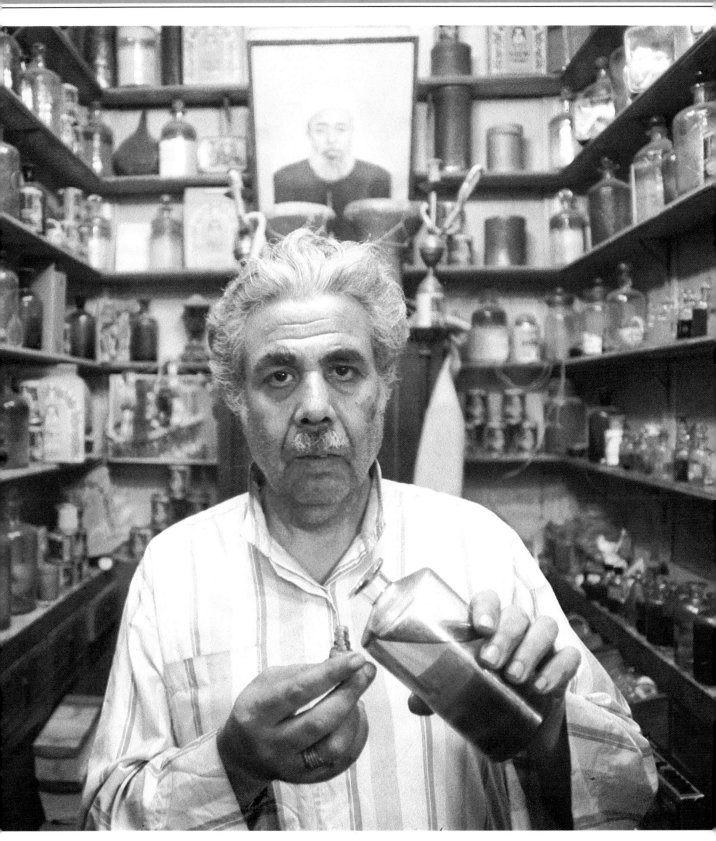

SETTING A STYLE

RICH AND OPULENT INTER-IORS challenge one's skill to express their colours, depth and atmosphere to full advantage. You need a lot of light, so take with you a main flash, slave unit, reflectors and a tripod. This sort of picture needs careful composing: pay particular attention to the arrangement of clothes, any interior props, furniture and other accessories. Don't over-illuminate, since you will wish to retain some mood and atmosphere.

The picture below was taken in Leighton House, London, once home of the Pre-Raphaelite painter Lord Leighton, who decorated the interior in an ornate, Arabic style. An interesting comparison is the theatrical, inventive and stylish home of dress-designer Zandra Rhodes, shown opposite.

Zandra Rhodes' home (right) had no white, reflective surfaces; so I used electronic flash bounced off portable reflectors. I allowed plenty of light to reveal the detail and give good depth.

In the Pre-Raphaelite scene (below) I dressed the model to harmonise with the interior. To maintain the low-light effect, I used a light source of diffused flash to one side, and another to show the background.

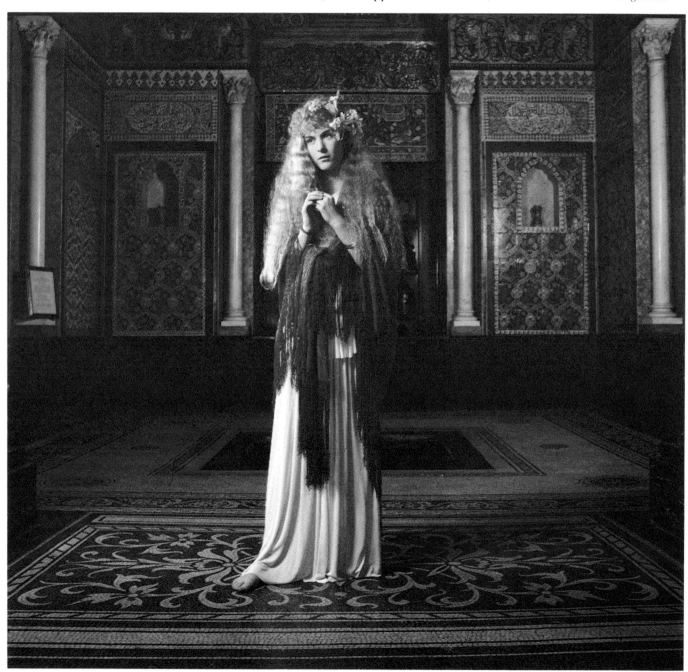

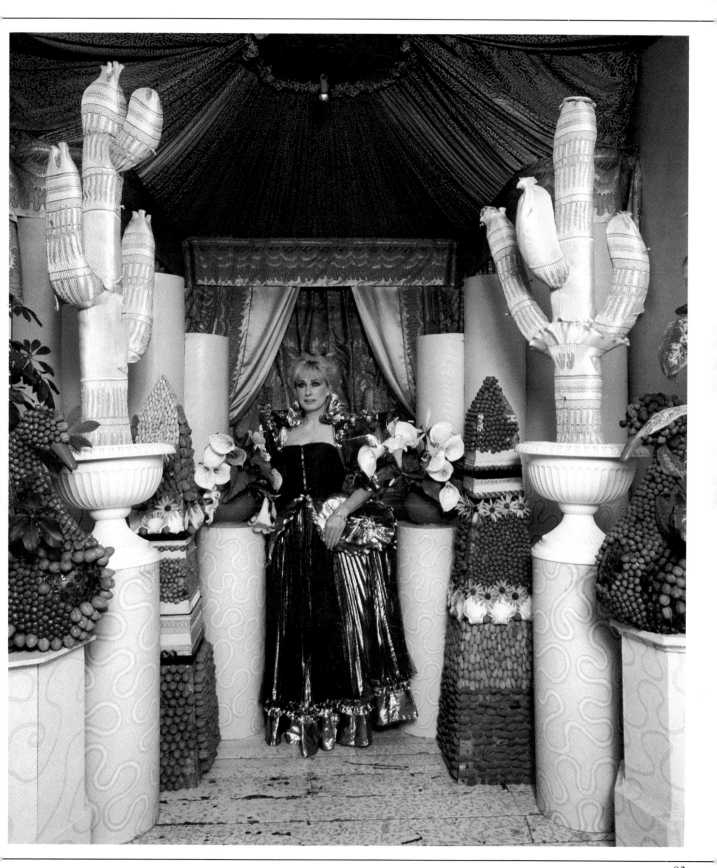

LIFESTYLES I

H UMAN INTEREST PICTURES
range from ordinary, down-to-
earth shots such as this French farmer
and his wife, to the splendidly ornate
lifestyle of the Cockney Pearly king and
queen.

People's lifestyles make endlessly
varied subjects, especially if you can
establish a sort of co-operative famili-
arity that breaks down the barriers of
self-consciousness. To shoot people at
work and at play, and from close range,
you have to learn to adopt an easy,
good-humoured but direct approach.

A successful picture will have
captured something of the person's
character, while at the same time pre-
serving the mood and atmosphere of
the moment. Whenever possible,
choose a setting that is representative of
your sitter. It is best to shoot in avail-
able light, or to use bounced flash for a
natural effect.

Life on the farm has an unmistakably Gallic
flavour in these shots (above and below),
confirmed by the 2CV car behind the smiling,
unshaven farmer, and by the Normandy cows
in the portrait of his wife.

An Englishman's home is his castle, ruled
here by the Pearly king and queen, whose
home setting is as ornate as their costume. A
diffused flash simulates daylight, to maintain
a natural atmosphere.

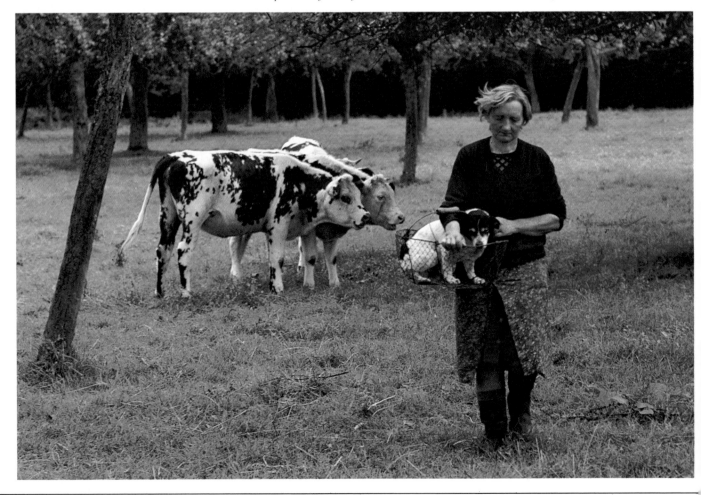

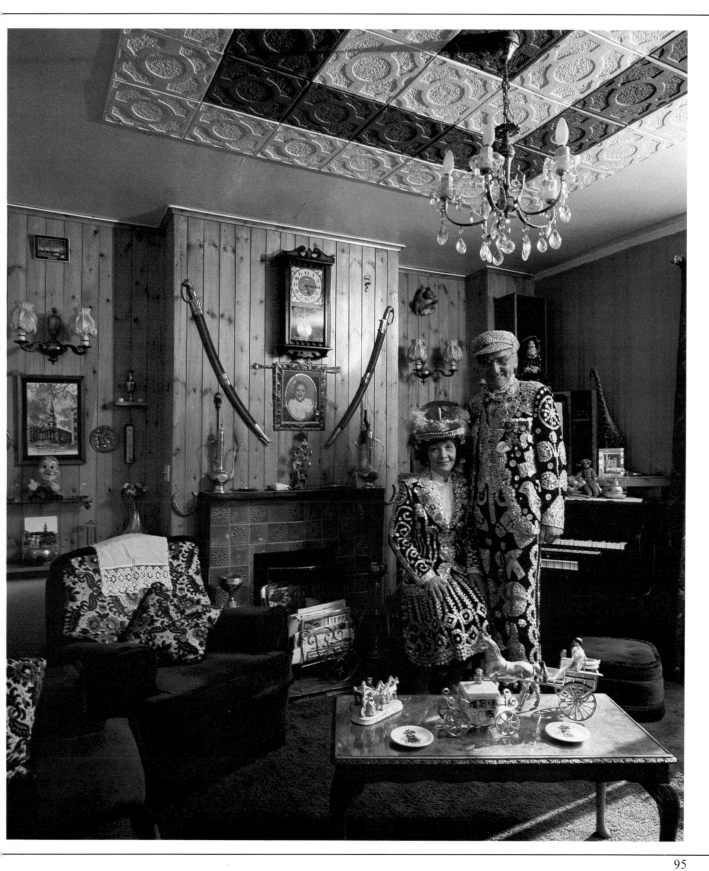

LIFESTYLES II

STATELY HOMES are often intrinsically a little "larger than life", and the camera must convey this feeling. A wide-angle lens allows you to exploit the broad, panoramic scope of the entire location; while including a sweeping foreground, with strong perspective lines, and small figures within the scene, helps to emphasise the grand scale. The somewhat feudal atmosphere in the pictures on these pages would have been lost without this approach.

In reality, these carefully-posed shots of stately homes and their owners are but formalised versions of the kind of picture which tourists take all the time – a member of the family posed in front of a famous building or monument, often with the added tongue-in-cheek implication of ownership and familiarity.

"Ownership" shots will be considerably weakened if there are other people wandering about in the scene, so it is best to confine your shooting to the early morning or later in the day. Another common error is placing the

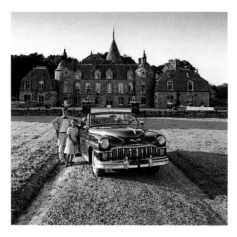

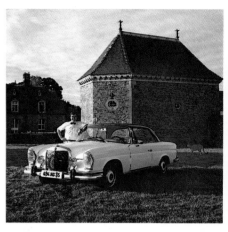

figure centrally, or too close to the camera, so that the building is partly obscured, the sense of scale lost, and the figure no longer looks "at home".

Pictures like these are a good exercise in composition: much depends on the viewpoint, the symmetry of framing, and the alignment of cars and figures. All the elements are related to the chateau, with everything from foreground to background in focus.

The long shadows of late afternoon (above and above left) have given these two scenes greater depth and contrast. The oblique view (above) gives a somewhat more informal result than the centred one.

An elevated camera position and wide-angle lens enabled me to separate the main features in both these shots (below and right) – the old lifestyle, and the new. The diagonal lines of the car, and the clipped yew pyramids, are strong compositional elements.

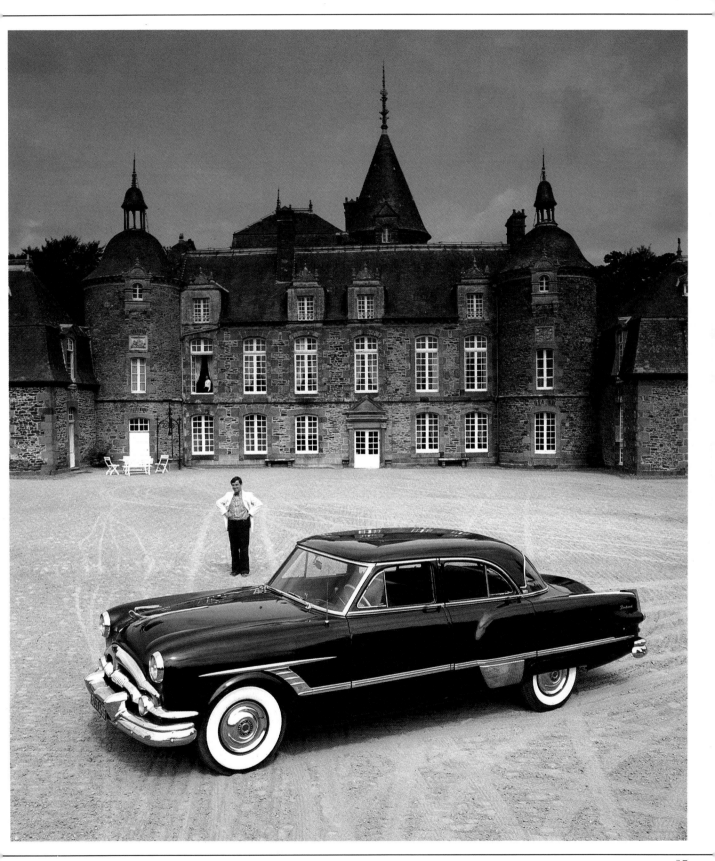

PAINTED IMAGES

THE BREAKAWAY FROM CONVENTIONAL imagery to the surreal and abstract photograph, from the real world to the world of illusion, was mainly due to the experiments of such painter-photographers as Man Ray, who made montages from photographic prints in the 1920s.

Today, a great range of surreal and bizarre effects are part of photography's language. The techniques themselves can be simple and straightforward – it is the arrangement and manipulation of the subject that reflect your imagination and creative skill.

The cat in the doorway (below) was a simple "found" image; so was the set for the man in grey. The sitter is the avant-garde American architect James Wines: one of his most famous creations is a supermarket with a piece that "pulls" away. I wanted to arrange an equally bizarre setting to photograph him in, and chose a showroom he had designed with everything painted a uniform grey. James Wines wore a grey shirt and glasses to blend in with the monochromatic scene.

"Found" images, such as the favourite cat painted on a farmhouse (below), make unusual photographs. The portrait (right) was shot in a painted set designed by James Wines for a fashion house.

LIGHT FANTASTIC

CREATING NEW IMAGES at home from your files of pictures is great fun, and there are limitless possibilities for experiment. With a simple slide projector, you can cast images on to a flat or curved surface – or even on to a live subject – and then rephotograph them. Another way is to juxtapose cut-out images from colour or black-and-white prints, magazines and posters, pasted on a flat or curved surface, and then rephotograph these montages, or use them as sets or backdrops. With a combination of these techniques, you can conjure up unusual and theatrical imagery by exploiting the versatility of screens, posters, theatre props and backdrops, the visually stunning outdoor murals that are now quite a common feature of our modern environment, and of course the marvellous world of reflections in windows and mirrors. All these offer excellent possibilities for creative photography.

The easiest way to photograph a projected image is to place your camera on a tripod, and just above the projector. You will need tungsten film (for slides) to record colours truly, since the projector lamp is balanced for this film, and exposures will be in the region of 1/8 to 1/4 second depending on the density of the transparency and the strength of illumination.

Projecting a slide of a mural on to a girl in a white leotard, against a white wall in a darkened room, has a dramatic result (below left). With a black card screen, you can eliminate the background (left). The projection set-up is shown in the diagram (above).

A familiar subject is transformed by using face paints (below) or theatrical set backdrops (right). I placed a model in a Rousseau-style setting, incidentally creating a three-dimensional effect. You could use a projected transparency for a similar result.

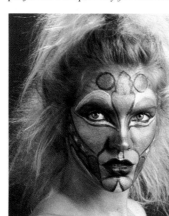

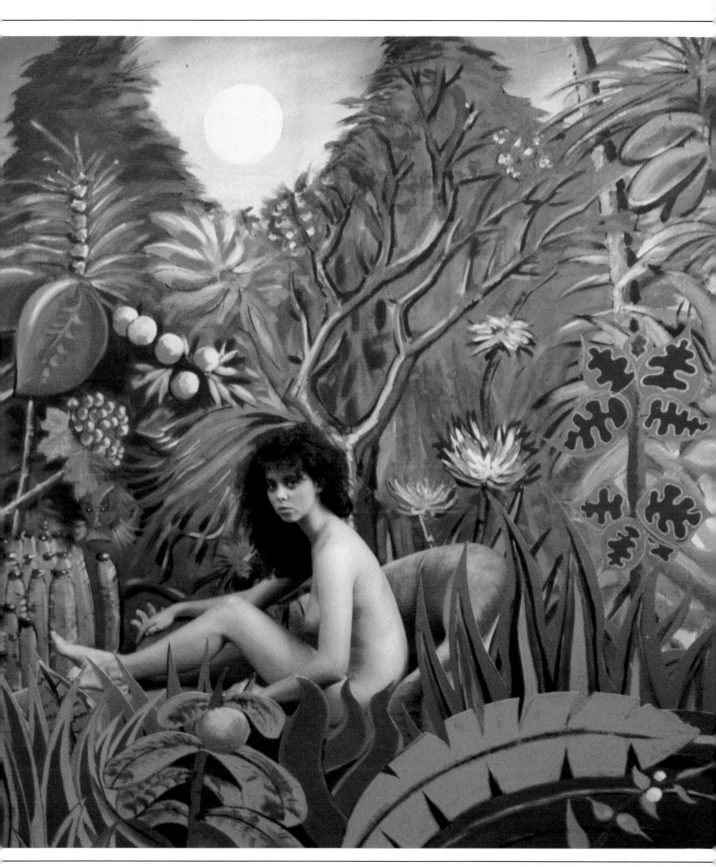

SPECIAL EFFECTS

ILLUSION AND DISTORTION are the domain of photography *par excellence*. The camera translates the world of three dimensions on to a two-dimensional, flat surface, and the viewer normally interprets the third dimension from obvious visual clues – the size and shading of objects, lines of perspective, and the visual information provided. It follows that the camera can trick the eye with false clues, to create bizarre and fantastic imagery.

The head-and-feet shot on the right could have been created in several ways – by double-printing from two negatives in the darkroom, for instance, or by enlarging and later joining two prints. Actually, this picture was made with a double-exposure filter on the camera – a much easier technique. The girl, dressed in a black sweater against a black background so that only her head was visible, was photographed on one half of a film frame through the open side of the filter. I then rotated the filter through 180° and exposed the lower half of the same frame to a close-up of her feet and hands against the black background.

The fantasy figure on the facing page, set against an ambiguous, surreal background, was painted to echo the theatrical setting. Her expression – is it horror, amazement, aggression? – is in keeping with the nightmare situation enforced by the menacing watch-headed figure and the curious perspective.

A double-exposure filter fits on to your camera lens and effectively divides the picture in half to allow two exposures on one frame. Some cameras have provision for double exposures; or you can press the rewind button (to prevent the film winding on) as you cock the shutter with the wind-on lever.

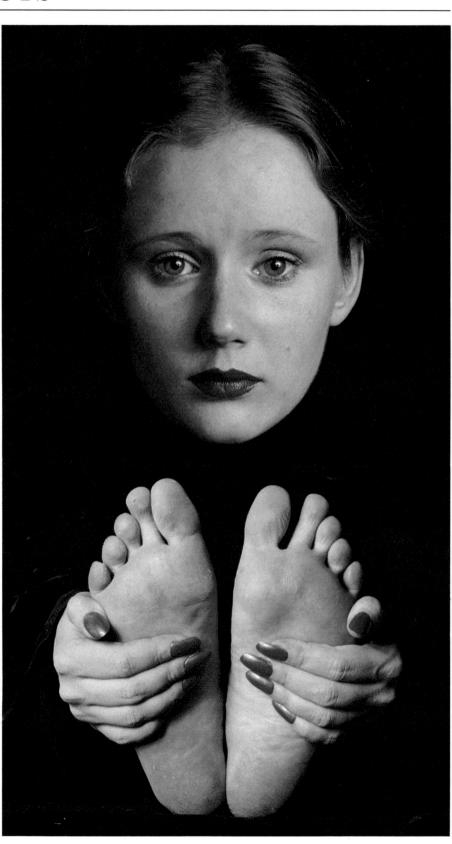

CLOSE ENCOUNTERS

PHOTOGRAPHS THAT CREATE FANTASY out of reality need not involve any technical wizardry. You can equally well exploit the medium with a conventional approach, either by manipulating the subject itself, as in these pictures, or simply by ignoring the rules. For example, you can deliberately throw the image out of focus, over- or underexpose the subject, use a slow shutter speed for a blurred image, jig the camera up and down while making a long exposure (creating interesting streaks of colour), or pan and zoom.

The girl (right) was shot through a shower-streaked bathroom door, the rivulets of water and condensation making an intriguing pattern on the surface. Special body-paint gives her an unearthly, other-world appearance, an effect heightened by the choice of colour, and by her wet hair.

She was photographed straight on, and in available light – it is the image, the subject itself, that breaks the bounds of convention, not the technique of the camera. Equally, the "Ophelia" picture (below) was carefully set up. The model floated in a blue, very shallow swimming pool, which gives a romantic, theatrical colour to the background, and flowers and water plants were added. The picture was shot by diffused daylight.

Imagination and planning are all you need to create fantasy images like these where the subject is carefully composed and set up, either with make-up (right) or by props, locations and attention to detail (below).

LOCAL COLOUR

TRAVEL PHOTOGRAPHS in specialist magazines usually present a scene in carefully-chosen and often idyllic surroundings. They depict an ideal, and very selective, point of view. The attractive scenery below gains by the inclusion of an additional subject – the group in the boat – that invests the shot with humour, and an indication of local lifestyles and transport. Far from waiting until they had passed beyond my angle of view, I was anxious to include them.

The more realistic and less picturesque views often provide informal, rewarding photographs, especially scenes with local colour (as on the right, and the following pages). Holiday travel can embrace almost every kind of photographic subject – landscapes, cityscapes, village life, sports, the working environment, even still-life and portraiture – shoot anything and everything that interests you. It can make a holiday more exciting and enjoyable and provide a permanent record of a place, its people and atmosphere. A selection of good travel shots should reveal as much about the people as

about the location.

You can ask inhabitants to pose for the camera, but it might raise the barriers of self-consciousness – tell your subjects that you would like to include them in your picture but request that they ignore you while shooting. Such informal or candid pictures are more likely to capture the spirit of the holiday and flavour of the scene: the shot on the right was unposed, although the figures nearest the camera were aware that I was shooting them – the couple at the table just didn't care!

Try to have your camera ready at all times so that you do not miss such moments. You will not always be able to get uncluttered backgrounds so remember that a low camera angle – as I have used here – can often minimize problem backgrounds.

Human interest always adds an enjoyable extra dimension to photographs of beauty spots, or of historic or characterful places. Although other travellers or holidaymakers can be a worthwhile subject, you will usually find that the locals themselves are more fascinating as subjects for photography.

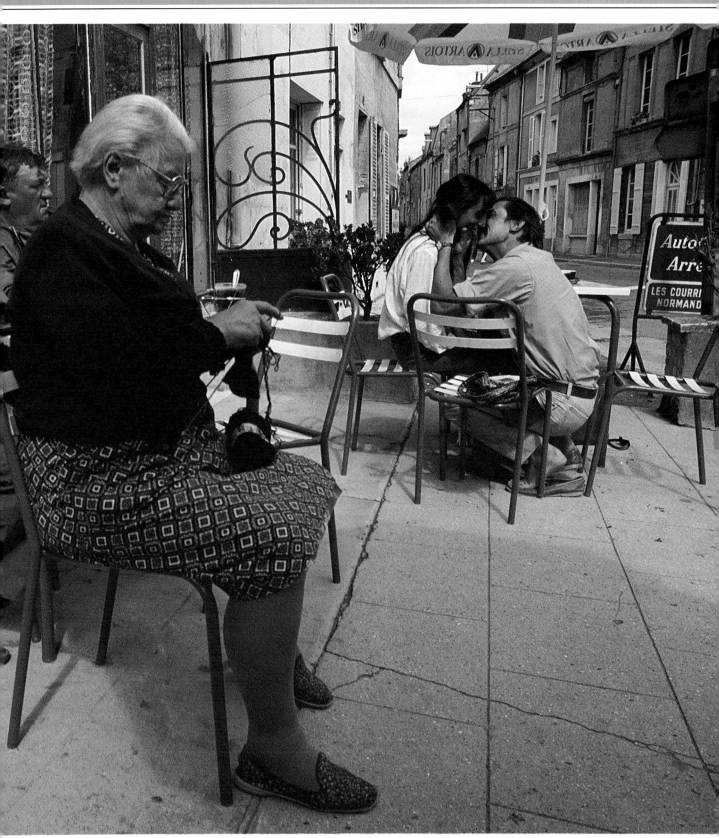

CITY LIMITS

CAPTURING THE SPIRIT of a
new environment in your travel or
holiday pictures is an exciting chal-
lenge. The stimulus of new sights,
sounds, and colours, and the unfamiliar
lighting conditions, all tend to awake
your interest and quicken your photo-
grapher's eye.

The character of a city takes much of

its inspiration from the style and spac-
ing of its buildings. Los Angeles, for
example, spreads its low-rise palm-lined
avenues far and wide; but New York's
Manhattan thrusts its glass, steel and
concrete towers skyward, an unforget-
table silhouette at sunset. It doesn't
take long to get the feel of a city, and
pick visual elements for a photo essay.

Don't just stay on the "sunny side of
the street", but exploit the adverse
conditions of rain, fog and snow, too.
These are all part of city life.

Try to avoid taking shots of build-
ings besieged by tourists – their brightly
coloured clothes will totally destroy any
historic atmosphere. On the other
hand, a few figures can give a sense of
scale. The best plan is to arrive very
early or very late, or settle for lunch-
time when there are less people about.
Take a tripod because you will need to
make long exposures of interiors –
small flash lights will illuminate only a
small area. Also, people tend to respect
the photographer with a tripod, and
keep well out of the scene. One useful
tip is that an exposure of over two
seconds, with your aperture stopped
right down, will not record moving
figures – they blur conveniently into the
background.

Some buildings may be tricky to
photograph because you cannot obtain
an overall view, or so well-known that
you want to find an unconventional
angle. Look for a vantage point from
where you can shoot a "different" view
with a long-focus or wide-angle lens.

Spirals, verticals and reflections are familiar
aspects of New York's cityscape. Such details
provide a pictorial theme for you to explore,
and form a valuable contribution to your
picture essay. As well as your standard lens,
take a 135mm for out-of-reach details, plus
a 28mm wide-angle.

A pet dog and its owner (right) in New
York's summer heat, is contrasted against the
facade of the Guggenheim Museum, a detail
of city life well worth recording. Equally
worthwhile is this panorama of Manhattan
island (below). You can take a tourist trip in
a helicopter to capture spectacular views.

FLAVOUR OF A CITY

OLIDAY PICTURES OF A CITY can be greatly improved with a modest degree of organisation, and by planning your photography around a theme – a picture series which explores a common motif or feature. Too often, people on vacation go around arbitrarily snapping popular views and famous monuments with little sense of purpose. The buildings may well be imposing works of art and

architecture – the Coliseum, the Eiffel Tower, or the Statue of Liberty – and worth including among your holiday snaps. But they have little to do with the real city, and fail to reflect the bustle and colour of a busy metropolis.

If you have some time (I took all the shots on this page in the space of half an hour), plan a strategy for a series of photographs based on one aspect of the city: people, posters, shop windows,

cab drivers and policemen, street signs, reflections – whatever catches your eye.

I was very aware when visiting New York of the visually arresting products and design of the fast-food cafés and restaurants, some with spectacular views (below). The food made an ideal subject for a series – brightly coloured and artfully presented, it reflected the jazzy, appealing atmosphere of this highly photogenic city.

Hot dogs, hamburgers and milk shakes *are now part of the folklore of New York. I chose fast food for a photo-essay on the city, and included aspects of restaurants and cafés. Good depth of field was vital, to show the food and the jazzy interiors to equal advantage. The pictures were shot in existing light, close to windows, with the camera mounted on a tripod.*

THEMES AND VARIATIONS

KEEP AN OPEN MIND, and a watchful eye out, for strong shapes or features that may lend themselves to a variety of treatments in a photo-essay. You can have great fun interpreting subjects in unexpected ways – by visual puns, for example. The travel shots here follow just this kind of approach: a powerful shape on a large

scale has inspired a series of pictures on a basic theme – the pyramid.

The pyramid was unencumbered by surrounding shapes, and I could get some distance away to vary the scale. This enabled me to play tricks like balancing the pyramid on the cocktail glass, making the girl appear to be offering a pyramid "cake", and show-

ing the sun as if it had just rolled down one side of the structure.

This type of picture demands great accuracy in your camera angles, focusing, and judgement of exposure, and you may have to wait some time for the right lighting. But patience, determination and perception are what photography is all about.

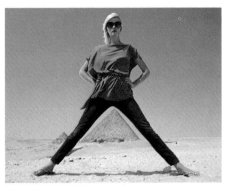
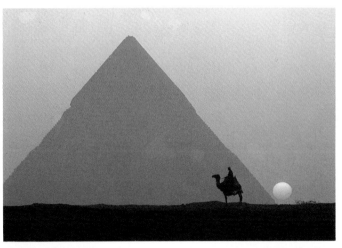
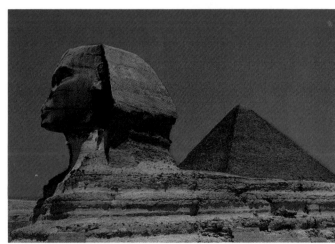

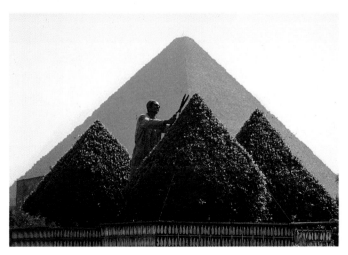

CAMERA, SLIDE AND PRINT CARE

Cases and hold-alls for photographic equipment come in various shapes and sizes (right). Rigid cases with foam rubber inserts offer the best protection. A lighter and cheaper type is the soft hold-all, but with this it is still necessary to keep camera, lenses and filters in individual cases as an additional protection against the careless knocks that happen all too often.

Proper care of cameras and lenses is essential for quality results. Cameras should be cleaned at least once a month. Remove the lens and use a blower brush to clear the inside of dust, with the shutter open on a T or B setting (left, 1). Don't leave the shutter cocked for any length of time, and if the camera is out of use for more than a week or so, remove the batteries. Lenses collect dust, grit and grease, but if cleaned too often the elements may become scratched. Avoid lens cloths: instead, use a rolled-up lens tissue to brush away loose particles (2). Always keep lenses in their cases with front and rear lens caps in place. The best way of protecting the front element is to fit UV or Skylight filters (3), which will not alter exposure or colour values.

Slides and negatives are best stored systematically. Slides must be kept in some form of dust-proof container and in a dry atmosphere. Plastic viewpacks (below, 1) are excellent for viewing a selection of transparencies simultaneously: they hold twenty slides in individual pockets, and may be stored in a deep filing drawer. Negatives can be stored in strips in special transparent envelopes, which should be kept in a negative cabinet, filing cabinet or loose-leaf album (such as a stationery ring-binder). It helps to identify negatives for future enlargement if you have contact prints made, and filed with the negatives (2). Systematic labelling is very important: it is useful to stick a piece of masking tape on each cassette or roll of film, to carry information about shots as you take them.

Dry mounting on heavy card is a good way of treating prints for wall display. Place the print face down on a clean surface. Lay mounting tissue on it and fix it to the centre of the print with a tacking iron (above, 1).

Turn the print over and, using a straight edge and craft knife, trim off excess tissue so that it is flush with the edges of the print (2). Turn the print over again and lay it on the card. Lift up each corner of the print and tack the

loose tissue to the card (3). Lay a sheet of clean paper over the print, and with an iron at a low setting apply even pressure from the centre outwards (4). Always ensure the print and card are absolutely dry.

GLOSSARY

Words in CAPITAL LETTERS **cross-refer to other entries within the glossary.**

Actinic (describing light) Able to affect photographic material. With ordinary film, visible light and some ULTRAVIOLET light is actinic, while INFRA-RED light is not.

Additive synthesis Method of producing full-colour image by mixing blue, green and red lights. These colours are called the additive primaries.

Aerial perspective Sense of depth in a scene caused by haze. Distant objects appear in gentler tones than those in the foreground and they tend to look bluish. The eye interprets these features as indicating distance.

Angle of view Generally taken to mean the maximum angle "seen" by a given lens. The longer the focal length of a lens, the narrower its angle of view.

Aperture Strictly, the opening that limits the amount of light reaching the film and hence the brightness of the image. In some cameras the aperture is of a fixed size; in others it is in the form of an opening in a barrier called the DIAPHRAGM and can be varied in size. Photographers, however, generally use the term "aperture" to refer to the diameter of this opening. See also F-NUMBER.

ASA American Standards Association, which devised one of the two most commonly used systems for rating the speed of an emulsion (i.e. its sensitivity). A film rated at 400 ASA would be twice as fast as one rated at 200 ASA and four times as fast as one rated at 100 ASA. The ASA system corresponds exactly with the more recent ISO system. See also DIN.

B setting Setting of the shutter speed dial of a camera at which the shutter remains open for as long as the release button is held down, allowing longer exposures than the preset speeds on the camera. The "B" stands for "brief" or "bulb" (for historical reasons). See also T SETTING.

Bellows Light-tight folding sleeve made of pleated cloth used to increase the distance between the lens and the camera body, for close-up work. Also used on large studio cameras.

Bloom Thin coating of metallic fluoride on the air-glass surface of a lens. It reduces reflections at that surface.

Blur Unsharp or ill-defined image caused by a moving subject, camera shake, unclear focusing or lens aberration. Blur is often unintentional and undesirable, but can be used to creative effect: by choosing a shutter speed too slow to "freeze" a moving subject, in which case it will appear blurred; or by "panning" with a moving subject so that it is sharply focused while the background is blurred.

Bounced flash Soft light achieved by aiming flash at a wall or ceiling or other reflective surface to avoid the harsh shadows that result if the light is pointed directly at the subject.

Bracketing Technique of ensuring perfect exposure by taking several photographs of the same subject at slightly different settings.

Cable release Simple camera accessory used to reduce camera vibrations when the shutter is released, particularly when the camera is supported by a tripod and a relatively long exposure is being used. It consists of a short length of thin cable attached at one end to the release button of the camera: the cable is encased in a flexible rubber or metal tube and is operated by a plunger.

Camera movements Adjustments to the relative positions of the lens and the film whereby the geometry of the image can be controlled. A full range of movements is a particular feature of large studio cameras, though a few smaller cameras allow limited movements, and special lenses are available which do the same for 35mm cameras.

Cartridge Plastic container of film, either 126 or 110. The film is wound from one spool to a second spool inside the cartridge.

Cassette Container for 35mm film. After exposure the film is wound back on to the spool of the cassette before the camera is opened.

CdS cell Photosensitive cell used in one type of light meter, incorporating a cadmium sulphide resistor, which regulates an electric current. See also SELENIUM CELL.

Coated lens See BLOOM.

Colour conversion filter Camera filter required when daylight colour film is used in artificial light, or when film balanced for artificial light is used in daylight.

Colour correction filter Filter used to correct slight irregularities in specific light sources (e.g. electronic flash). The name is also used to describe the cyan, magenta and yellow filters which are used to balance the colour of prints made from colour negatives.

Colour synthesis Additive or subtractive methods by which a final colour photograph is formed.

Colour temperature Measure of the relative blueness or redness of a light source expressed in KELVINS. The colour temperature is the temperature to which a theoretical "black body" would have to be heated to give out light of the same colour.

Complementary colours Two colours that together produce white light. Colour filters absorb light of the complementary colour. Complementaries of the three primary colours red, green and blue, are cyan, magenta and yellow respectively. Also used to denote colours opposite each other in the colour wheel.

Contrast Differences between light and dark tones in a subject or image and also between colours that lie opposite each other on the colour wheel.

Converging verticals Distorted appearance of vertical lines in the image, produced when the camera is tilted upwards: tall objects such as buildings appear to be leaning backward. Can be partially corrected at the printing stage, or by the use of CAMERA MOVEMENTS.

Correction filter Coloured filter used over the camera lens to modify the tonal balance of a black and white image.

Cropping Enlarging only a selected portion of the negative instead of printing the entire area.

Depth of field Zone of acceptable sharpness extending in front of and behind the point on the subject which is exactly focused by the lens. Depth of field may be adjusted by varying the aperture.

Developer Chemical agent which converts the LATENT IMAGE into a visible image.

Diaphragm System of adjustable metal blades forming a roughly circular opening of variable diameter, used to control the APERTURE of a lens. An iris diaphragm forms a continuously variable opening, while a stop plate has a number of holes of varying sizes.

Diffusion Scattering of light passing through a translucent but not transparent medium such as tracing paper or a smoky atmosphere. Diffused light is softer and lower in contrast.

DIN Deutsche Industrie Norm, the German standards association, which devised one of the two widely used systems for rating the speed of an emulsion (see also ASA and ISO). On the DIN scale, every increase of 3 indicates that the sensitivity of the emulsion has doubled. 21 DIN is equivalent to 100 ASA.

Double exposure Exposing the same piece of film or light-sensitive paper twice.

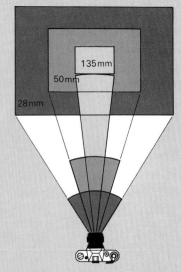

Angles of view of three of the most popular lenses for 35mm cameras

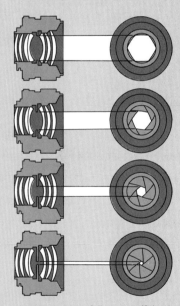

Aperture shown fully open at f2 (top) and closing down to f22 (bottom)

Bellows unit

GLOSSARY

Exposure meter

Fish-eye effect

Focusing screens

Grain

Electronic flash Type of FLASHGUN which uses the flash of light produced by a high-voltage electrical discharge between two electrodes in a gas-filled tube.

Emulsion In photography, the light-sensitive layer of a photographic material. The emulsion consists essentially of silver halide crystals suspended in gelatine.

Enlargement Photographic print larger than the original image on the film.

Exposure Total amount of light allowed to reach the light-sensitive material during the formation of the LATENT IMAGE. The exposure is dependent on the brightness of the image, on the camera APERTURE and on the length of time for which the photographic material is exposed.

Exposure latitude Tolerance of photographic material to variations in exposure.

Exposure meter Instrument for measuring the intensity of light so as to determine the correct SHUTTER and APERTURE settings.

Extension tubes Accessories used in close-up photography, consisting of metal tubes that can be fitted between the lens and the camera body, thus increasing the lens-to-film distance.

Film speed A film's degree of sensitivity to light, usually expressed as a rating on either the ASA (or ISO) or DIN scales.

Filter Transparent sheet, usually of glass or gelatin, used to block a specific part of the light passing through it, or to change or distort the image in some way. See also COLOUR CONVERSION FILTER, COLOUR CORRECTION FILTER, CORRECTION FILTER, POLARISING FILTER.

Fisheye lens Extreme wide-angle lens with an ANGLE OF VIEW of about 180°. Since its DEPTH OF FIELD is almost infinite, there is no need for any focusing, but it produces images that are highly distorted.

F-number Number resulting when the FOCAL LENGTH of a lens is divided by the diameter of the aperture. A sequence of f-numbers, marked on the ring or dial which controls the DIAPHRAGM, is used to calibrate the aperture in regular steps (known as STOPS) between its smallest and largest settings. The f-numbers generally follow a standard sequence such that the interval between one stop and the next represents a halving or doubling in the image brightness. As f-numbers represent fractions, the numbers become progressively higher as the aperture is reduced to allow in less light.

F-stop See F-NUMBER.

Filter factor The amount by which exposure has to be adjusted to compensate for the light-blocking powers of a filter.

Flare Light reflected inside the camera or between the elements of the lens, giving rise to irregular marks on the negative and degrading the quality of the image. It is to some extent overcome by using bloomed lenses (see BLOOM).

Flash exposure Calculated by means of a guide number, stated for the particular flash unit and film being used. The flash-subject distance (in feet or metres according to the guide system used) is divided into this number. The result is the approximate APERTURE setting.

Flash umbrella Reflective umbrella used to bounce light from a flash or other light source on to the subject.

Flashgun. Source of artificial, high-intensity light of very short duration – 1/1000 second or less – balanced to approximate daylight, and designed as a compact, lightweight unit that can be mounted on the camera's HOT SHOE. The majority are now computerised; that is, they automatically adjust the intensity of the light to the aperture setting. *Dedicated* flash guns are made for one specific model or range of cameras to enable light output, aperture and shutter speed to be synchronised perfectly.

Focal length In the case of a simple lens, the distance between the lens and the position of a sharply focused image when the lens is focused at infinity.

Focal plane Plane on which a given subject is brought to a sharp focus; plane where the film is positioned.

Focal-plane shutter One of the two main types of shutter, used almost universally in SINGLE-LENS REFLEX CAMERAS. Positioned behind the lens (though in fact slightly in front of the focal plane) the shutter consists of a system of cloth blinds or metal blades; when the shutter is activated, a slit travels across the image area either vertically or horizontally. The width and speed of travel of the slit determine the duration of the exposure.

Focus magnifier Device that magnifies the grain of a negative, as projected by an enlarger, allowing a sharply focused image to be seen.

Focusing The adjustment of lens-to-film distance to produce a sharp image of the subject. Closer subjects require greater lens-to-film distance.

Focusing screen Etched glass or plastic used on a camera as an aid to observing and focusing the image before exposure.

Fog Veiling of an image caused by light leak to the emulsion, by

chemical means or by poor or over-long storage. Chemical or poor storage fog can be minimised by adding an antifoggant chemical to the developer.

Format Dimensions of the image recorded on film by a given type of camera. The term may also refer to the dimensions of a print.

Glazing Imparting a high glaze to glossy-surface printing papers by drying them in close contact with a high-glaze surface, usually with the addition of heat.

Grain Granular texture appearing to some degree in all processed photographic materials. In black and white photographs the grains are minute particles of black metallic silver which constitute the dark areas of a photograph. In colour photographs the silver has been removed chemically, but tiny blotches of dye retain the appearance of graininess. The faster the film, the coarser the texture of the grain.

Guide number Number indicating the effective power of a flash unit. For a given film speed, the guide number divided by the distance between the flash and the subject gives the appropriate F-NUMBER to use.

Halation Phenomenon characterised by a halo-like band around the developed image of a bright light source. Caused by internal reflection of light from the support of the emulsion (i.e., the paper of the print or the base layer of a film).

Halogens A particular group of chemical elements, among which chlorine, bromine and iodine are included. These elements are important in photography because their compounds with silver (silver halides) form the light-sensitive substances in all photographic materials.

High-key Containing predominantly light tones. See also LOW-KEY.

Highlights Brightest areas of the subject, or corresponding areas of an image: in the negative these are areas of greatest density.

Hot shoe Accessory shoe on a camera which incorporates a live contact for firing a flashgun, thus eliminating the need for a separate contact.

Hyperfocal distance The shortest distance at which a lens can be focused to give a DEPTH OF FIELD extending to infinity. (In fact, it then extends from half the hyperfocal distance to infinity.)

Incident light Light falling on the subject. When a subject is being

photographed, readings may be taken of the incident light instead of the reflected light.

Infra-red radiation Part of the spectrum of electromagnetic radiation, having wavelengths longer than visible red light (approximately 700 to 15,000 nanometres). Infrared radiation is felt as heat, and can be recorded on special types of photographic film. See IR SETTING.

IR (infra-red) setting A mark sometimes found on the focusing ring of a camera, indicating a shift in focus needed for infra-red photography. INFRA-RED RADIATION is refracted less than visible light, and the infrared image is therefore brought to a focus slightly behind the visible image.

Iris diaphragm See DIAPHRAGM.

ISO International Standards Organisation, which has devised the most recent system for rating the speed of an emulsion. The ISO rating is exactly the same as the ASA rating: i.e., 400 ASA equals ISO 400.

Kelvin (K) Unit of temperature in the SI system of units. The Kelvin scale begins at absolute zero ($-273°C$) and uses degrees equal in magnitude to 1°C. Kelvins are used in photography to express COLOUR TEMPERATURE.

Latent image Invisible image recorded on photographic emulsion as a result of exposure to light. The latent image is converted into a visible image by the action of a developer.

LED See LIGHT-EMITTING DIODE.

Lens Device of glass or other transparent material used to form images by bending and focusing rays of light.

Lens hood Simple lens accessory, usually made of rubber or light metal, used to shield the lens from light coming from areas outside the field of view. Such light is the source of FLARE.

Light-emitting diode (LED) Solid state electrical component used as a glowing coloured indicator inside a camera viewfinder or other photographic apparatus to provide a visual signal or warning indicator for various controls.

Linear perspective Apparent diminution of size and convergence of lines with distance. See also AERIAL PERSPECTIVE.

Long-focus lens Lens of focal length greater than that of the STANDARD LENS for a given format. Long-focus lenses have a narrow field of view, and consequently make distant objects appear closer. See also TELEPHOTO LENS.

Low-key Containing predominantly dark tones. See also HIGH-KEY.

Macro lens Strictly, a lens capable of giving a 1:1 magnification ratio (a life-size image); the term is generally used to describe any close-focusing lens. Macro lenses can also be used at ordinary subject distances.

Motor drive Battery-powered camera accessory used to wind on the film automatically after each shot, capable of achieving a rate of several frames a second.

Negative Image in which light tones are recorded as dark, and vice versa; in colour negatives every colour in the original subject is represented by its complementary colour.

Orthochromatic Term used to describe black-and-white emulsions that are insensitive to red light. See also PANCHROMATIC.

Panchromatic Term used to describe black-and-white photographic emulsions that are sensitive to all the visible colours (although not uniformly so). Most modern films are panchromatic. See also ORTHOCHROMATIC.

Panning Technique of swinging the camera to follow a moving subject, used to convey the impression of speed. A relatively slow shutter speed is used, so that a sharp image of the moving object is recorded against a blurred background.

Parallax Apparent displacement of an object brought about by a change in viewpoint. Parallax error is apparent in close-ups only, shown in the discrepancy between the image produced by the lens and the view seen through the viewfinder in cameras where the viewfinder and taking lens are separate.

Photoflood Bright tungsten filament bulb used as an artifical light source in photography. The bulb is over-run and so has a short life.

Polarised light Light vibrating in one plane instead of in all directions at right angles around its line of motion. The polarisation of specularly reflected light produces glare.

Polarising filter Thin transparent filter used as a lens accessory to cut down reflections from certain shiny surfaces (notably glass and water) or to intensify the colour of a blue sky. Polarising filters are made in the form of a screen that blocks a proportion of light that has already been polarised: rotating the filter will vary the proportion that is blocked.

Positive Image in which the light tones correspond to the light areas of the subject, and the dark tones

correspond to the dark areas; in a positive colour image, the colours of the subject are also represented by the same colours in the image. See NEGATIVE.

Primary colours In the ADDITIVE SYNTHESIS of colour, blue, green and red. Lights of these colours can be mixed together to give white light or light of any other colour.

Prism Transparent medium, often of basic triangular shape, capable of bending (or refracting) light. See REFRACTION.

Projector Apparatus for throwing an image from a transparency on to a screen. Typically, the system employs a projector lamp (usually a tungsten filament type), a condenser, cooling fan, slide magazine and lens. Circular magazines have greater capacity than simple push-pull carriers, holding up to 100 35mm slides. They are used with the more expensive carousel-type projector, operated by remote control (and sometimes with automatic focusing).

Rangefinder Optical device for measuring distance, often coupled to the focusing mechanism of a camera lens. A rangefinder displays two images, showing the scene from slightly different viewpoints, which must be superimposed to establish the measurement of distance.

Ready light Neon lamp on flashguns indicating when the batteries have recycled and are ready to fire again.

Reciprocity law Principle according to which the density of the image formed when an emulsion is developed is directly proportional to the duration of the exposure and the intensity of the light. However, with extremely short or long exposures and with unusual light intensities the reciprocity law fails to apply and unpredictable results occur. This is known as reciprocity failure.

Reflex camera Genetic name for types of camera whose viewing systems employ a mirror to reflect an image on to a screen. See TWIN-LENS REFLEX CAMERA and SINGLE-LENS REFLEX CAMERA.

Refraction The bending of light as it passes from one transparent medium to another of different density (e.g. a lens element).

Reversal film Photographic film which, when processed, gives a positive image; that is, intended for producing slides rather than negatives.

Reversing ring Camera accessory which enables the lens to be attached back to front. Used in close-up photography to achieve higher-image quality and greater magnification.

High-key

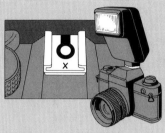
Hot shoe

Macro photography

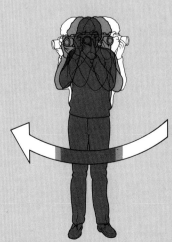
Panning

GLOSSARY

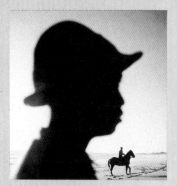

Selective focusing

Soft-focus effect

Wide-angle portrait

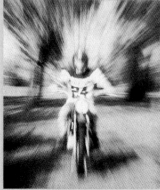

Zooming during exposure

Selective focusing (also known as differential focusing) Method of utilising minimum depth of field to emphasise a particular area of the subject, isolating it against an unsharp background or foreground.

Selenium cell One of the principal types of photoelectric cell used in light meters. A selenium cell produces a current when stimulated by light, proportional to the intensity of the light.

Shutter Camera mechanism which controls the duration of the exposure. The main types in use are the FOCAL-PLANE SHUTTER, employed on 35mm and small-format cameras, and the between-the-lens leaf shutter used on medium and large-format cameras.

Shutter speed The length of time a shutter stays open to govern duration of exposure. Speeds are in fractions of a second, beginning at 1 second, then ½ second, and in fractions up to 1/1000. Most cameras have a speed synchronised for electronic flash – the "X" setting, which varies according to the camera, but is generally either 1/60 or 1/125 second.

Silica gel Moisture-absorbing crystals used to keep cameras and photographic material dry. Can be dried out and re-used.

Silicon cell Light-sensitive cell used in some fast-reacting THROUGH-THE-LENS light meters. Requires battery power.

Single-lens reflex camera (SLR) One of the most popular types of camera design. Its name derives from its viewfinder system, which enables the user to see the image produced by the same lens that is used for taking the photograph. A hinged mirror reflects this image on to a viewing screen where the picture may be composed and focused: when the shutter is released, the mirror flips out of the light path while the film is being exposed.

Slave unit Photoelectric device used to trigger electronic flash units in studio work. The slave unit detects light from a primary flashgun linked directly to the camera, and fires the secondary flash unit to which it is connected.

SLR See SINGLE-LENS REFLEX CAMERA.

Soft focus Slight diffusion of the image achieved by the use of a special filter or similar means, giving a softening of the definition. Soft-focus effects are generally used to give a gentle romantic haze to a photograph.

Soft-focus lens Any lens incapable of pin-point definition. Filters are available to make an image less critically sharp intentionally.

Spectrum The multicoloured band obtained when light is split up into its component wavelengths, as when a prism is used to split white light into coloured rays; the term may also refer to the complete range of electromagnetic radiation, extending from the shortest to the longest wavelengths and including visible light.

Spotlight Lamp utilising a reflector and movable lens to control the spread of light.

Spot meter Special type of light meter which takes a reading from a very narrow angle of view; in some THROUGH-THE-LENS METERS the reading may be taken from only a small central portion of the image in the viewfinder.

Standard lens Lens of focal length approximately equal to the diagonal of the negative format for which it is intended. In the case of 35mm cameras the standard lens usually has a focal length in the range of 50-55mm, slightly greater than the actual diagonal of a full frame negative (about 43mm).

Stop Alternative name for aperture setting or **F-number**.

Stopping down Colloquial term for reducing the aperture of the lens. See also STOP.

Sync lead Cable between a flashgun and the camera body, which fires the flash at the moment of releasing the shutter.

T setting Abbreviation of "time" setting – a mark on some shutter controls. The T setting is used for long exposures when the photographer wishes to leave the camera with its shutter open. The first time the shutter release is pressed, the shutter opens; it remains open until the release is pressed a second time. See also B SETTING.

Telephoto converter Auxiliary glass elements, which when used with the prime lens magnify a part of the image of the prime lens to simulate a lens of greater focal length.

Telephoto lens Strictly, a special type of LONG-FOCUS LENS, having an optical construction which consists of two lens groups; the front group acts as a converging system, while the rear group diverges the light rays. This construction results in the lens being physically shorter than its effective focal length.

TLR See TWIN-LENS REFLEX CAMERA.

Tone Refers to the range of greys between black and white, and variations of strength of colours. All pictures have a tonal range, unless they are silhouettes. The greys between black and white can be mixed with colour to produce tones.

Transparency A photograph viewed by transmitted rather than reflected light. When mounted in a rigid frame, the transparency is called a slide.

Through-the-lens meter (TTL) Built-in exposure meter which measures the intensity of light in the image produced by the main camera lens. Principally found in more sophisticated designs of SINGLE-LENS REFLEX CAMERA.

TTL See THROUGH-THE-LENS METER.

Tungsten lighting Light source with a tungsten filament inside a glass envelope.

Twin-lens reflex camera (TLR) Type of camera whose viewing system employs a secondary lens of focal length equal to that of the main "taking" lens: a fixed mirror reflects the image from the viewing lens up onto a ground-glass screen. Twin-lens reflex cameras suffer from PARALLAX error, particularly when focused at close distances, owing to the difference in position between the viewing lens and the taking lens. See also SINGLE-LENS REFLEX CAMERA.

Ultraviolet (UV) Part of the invisible SPECTRUM with a wavelength shorter than that of blue light. Makes distant scenes appear hazy and causes a blue colour distortion.

UV filter Filter used over the camera lens to absorb ULTRA-VIOLET radiation, which is particularly prevalent on hazy days. A UV filter enables the photographer to penetrate the haze to some extent. UV filters, having no effect on the exposure, are sometimes kept permanently in position over the lens to protect it from damage.

Viewfinder Window or frame on a camera, showing the scene that will appear in the picture, and often incorporating a RANGEFINDER mechanism.

Wide-angle lens Lens of focal length shorter than that of a STANDARD LENS, and consequently having a wider ANGLE OF VIEW.

X-setting The camera setting for electronic flash. On cameras with FOCAL-PLANE SHUTTERS the X-setting is generally synchronized with a shutter speed of 1/60 or 1/125, depending on the make of camera.

Zoom lens Lens of variable FOCAL LENGTH whose focusing remains unchanged whilst its focal length is being altered. Zooming is accomplished by changing the relative positions of some of the elements within the lens.

INDEX

INDEX

Acknowledgements

The following people and organisations merit particular thanks for their help in the creation of this book:

Mme de l'Acretelle, Mr T. Andrews, Adrian Bailey, Lorna Booth, Judy Davison, Fia and Keeley, Rev. Jack Filby, Eric Gilboy, Mr and Mrs Hassani, Carol Hayes, Julia Hedgecoe, Fred and Louie Hitchen, Miss Lillian Judges, Mr Leach, Le Comte de Lorgeril, Mrs Christina Marshall, Paul McConkey, Amanda McGaw, Frederica Morton, Terry Nightingall, Val Outram, Mr and Mrs Pedley, Pentax Cameras, Roy Pratt, Zandra Rhodes, Mr Saunders, Tony and David Smith, Caroline Spack, Sheila Stirrat, Catherine Sullivan, Ian Voight, Wansey (Carla), Tony Warburton, Jane Wood, Maggie Young.

The author and publishers would also like to thank City Camera Exchange Ltd and Leeds Camera Centre Ltd (both of London) for the loan of equipment for the photograph on page 8.

What a Picture!
TV and Video Series
Production Team

Executive Producer
 Mick Csaky
Co-producer
 Lawrence Moore
Producer-Director
 Chris Haws
Editor
 Alan Coddington
Cameraman
 Terence Bulley
Designer
 Malcolm Lewis